CONTENTS

FOREWORD

Glasgow Museums welcomes the opportunity to collaborate with Chambers on this attractively illustrated guide to the stained glass in The Burrell Collection. This important part of Sir William's collection is very popular with visitors and forms the second largest museum collection of its type in Europe. There are some 700 panels ranging in scale from complete windows to tiny fragments dating from the 12th to the 19th centuries. From their quality it is clear that Burrell chose to purchase the best examples available from each era and each country that interested him.

Linda Cannon has been the stained glass conservator for Glasgow Museums since 1984. She is an Associate Member of the British Society of Master Glass Painters and a member of the Technical Committee affiliated to Corpus Vitrearum Medii Aevi. For this book, she has drawn on research carried out by two former Keepers of the Burrell Collection, William Wells and Richard Marks, to whom our thanks are due. She has also contributed an historical survey of the techniques involved in the manufacture of coloured glass and how it was made into windows, with particular reference to the glass in the Burrell.

Many people have helped with this book, giving their time and assistance in various ways including Mrs Neilson and Mrs Hume of Edinburgh, also Kathleen Buchanan, Hazel Cannon, Priscilla Dorward, Ian Fraser and Valerie Harper, as well as many members of Glasgow Museums staff.

Julian Spalding
Director
Glasgow Museums 1991

HISTORY OF
THE COLLECTION

 N 1892, at the age of 31, William Burrell commissioned George Walton to design and make a stairhead window for his house at 4 Devonshire Gardens in Glasgow (Fig 1). This is the earliest record of Burrell's interest in stained glass.[1] At first it appears surprising that a collector, who was later to acquire over 700 medieval windows, should ask a relatively unknown local artist to make a new window in a contemporary style rather than one of the many large stained glass firms who were working on Neo-Gothic designs. However, when one looks more closely at the climate of opinion and controversy that surrounded stained glass in Glasgow towards the end of the 19th century, Sir William's preference becomes more understandable.

All indigenous medieval stained glass in Glasgow had been destroyed from the mid-16th century onwards, following the Orders in Council in 1560 which demanded the destruction of all images. A persistent reluctance to see stained glass as anything other than a graven image meant that the revival of interest in this particular art form occurred much later in the west of Scotland than elsewhere in Britain. The writings of Sir Walter Scott (1771–1832) encouraged many people to take a renewed interest in the romance of the Middle Ages, which, in turn, revived an interest in the arts and crafts of the period, of which stained glass was one of the most important.[2] The economic boom in Glasgow, which began in the late 18th century and continued throughout the 19th century, aroused public awareness in the adornment of public and private buildings with decorative

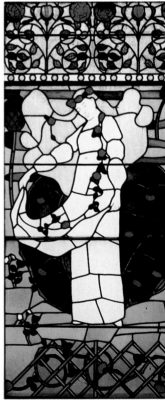

1 **Gather Ye Rosebuds While Ye May,**
Detail, George Walton, 1892,
stairhead window, 4 Devonshire Gardens

art. The turning point for the stained glass revival in Glasgow came in 1843 when one-third of the clergy left the established Church of Scotland to form the Free Kirk. With them went the extreme Calvinist theology which had severely restricted the use of representational art.

In the 1850s it was decided that the Gothic cathedral should be re-glazed, to put colour back into windows previously filled for 300 years with plain glass. Instead of encouraging local artists to carry out this work, the commission went to the Royal Establishment of Glass Painting in Munich, superintended by Max Ainmuller. The choice of this particular firm had been the decision of Charles Winston,[3] a barrister from London, who in 1847 had published *Hints on Glass Painting* – a study of the different styles of stained glass from its origins right through to the time of writing. Although he considered himself an amateur, his book had a profound effect on the development of stained glass, not only in educating people about the history of the craft, but also because he liberally peppered the text with his own very personal opinions about what was good or bad art. He greatly admired stained glass from the Middle Ages, but despised Neo-Gothic art, considering it mere archaeological learning and a slavish copying of past styles. His sentiments were championed by the stained glass artists of Glasgow[4] and he was revered as being the foremost authority of his day, and therefore the natural choice for recommending a company to re-glaze the cathedral – until the commission was given and glass was in place. Although the windows were not at first universally disliked by the public,[5] they did create an atmosphere of darkness and depression in the restored building. The grey light of rainy Glasgow, and the soot and smog of industrial pollution did nothing to enhance their transparency, and within 80 years they were removed. The artists of the embryonic stained glass movement in Glasgow were outraged that such a major commission should not have been given to them. Already having turned their back on Neo-Gothic art, they now also despised the high-Victorian monumentalism of the Munich windows. They looked instead for inspiration from classicism, the arts and crafts movement pioneered by William Morris and the arts from the Far East.

It was in this environment that Burrell formed his taste for stained glass, the latter influences being clearly identifiable in the Walton window. Whether or not Burrell thought the venture into contemporary stained glass was successful is open to conjecture, but perhaps it is significant that he never again commissioned a new window.

Around this time he is known to have owned a small assortment of medieval and Renaissance panels, most of which he subsequently sold in the 1930s.[6] An early indication of the size of his growing collection of medieval stained glass came with the 1901 International Exhibition held in Kelvingrove Park in Glasgow. Sir William was the lender of the largest

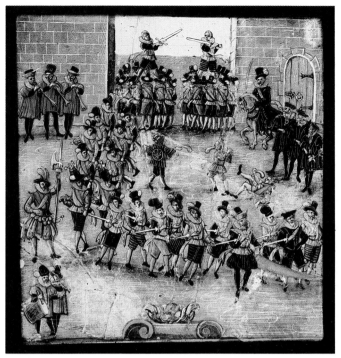

2 **Pageant and Mock Tournament** *(45/499), Swiss, 16th century*

collection of art objects to the exhibition, over 200, among which were three 16th-century German panels and two cases filled with an assortment of window and vessel glass.[7] A complete catalogue for the exhibition exists, but the entries are frustratingly vague: 'Ancient Glass, Dutch glass – coat of arms – 17th century', and so on. Consequently only one or two panels can now be correctly identified. One of these is a tiny Swiss panel from the 16th century which is intricately painted in enamels and yellow-stain, illustrating a *Pageant and Mock Tournament* (Fig 2). In the centre of the panel a smartly dressed column of soldiers is led round a courtyard by two officers. The group marches past a commanding officer on horseback and three standing officials whilst a fanfare of trumpets and drums is played in the background. Two mock fights are staged with swords and sacks to the obvious consternation of some of the soldiers. The panel is both charming and humorous, and a remarkable piece of glass painting on a square of glass that measures less than 18 cm (7 in) across.

Evidence of other windows that belonged to Burrell at this time can be seen in contemporary photographs of his house, 8 Great Western Terrace in Glasgow (Fig 3 and Appendix 1). One of these is another comical little 16th-century German octagonal panel showing seven women gleefully

3 **8 Great Western Terrace**

beating a pair of man's trousers with anything they have to hand: a broom, a knife, a shovel, a distaff and a set of keys (Fig 4).

Both this window and the *Mock Tournament* reveal that even at an early stage Sir William's sense of humour affected his collecting taste, a fact that is borne out by the charming, and often funny, incidental details in the windows.

It was after 1918 that Burrell began collecting glass in earnest. World events played their part in his success. He had made a fortune from the sale of ships during World War I, and in the economic depression that followed he prudently avoided the fate of many of the great American and European private collectors, that of bankruptcy, caused by debt and financial mismanagement. Two men from whom Burrell was to benefit greatly were the American newspaper magnate William Randolph Hearst, and Sir George Jerningham, of Costessey Hall, Norfolk.

At the beginning of the 19th century Sir George Jerningham's father, Sir William, built a chapel in his stately home at Costessey specifically to house a vast collection of European medieval stained glass. Some of this collection may have been brought over by the family while on the Grand Tour, but the majority of it was most likely to have been acquired through the travels of one man, John Christopher Hampp, who was a cloth merchant from Norwich.[8] The upheavals in Europe immediately following the French Revolution caused so much turmoil and financial crisis that the churches were often forced to sell their gold and silver and sometimes even the very fabric of the buildings themselves, including their stained glass. This, combined with a fashion for classical simplicity

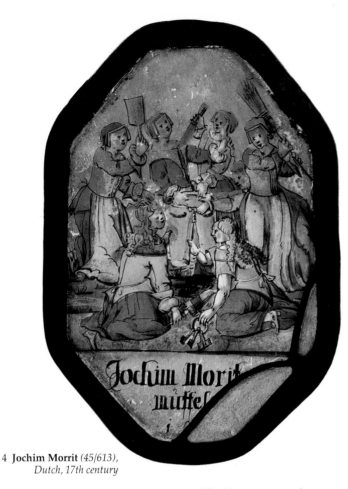

4 **Jochim Morrit** *(45/613),*
Dutch, 17th century

rather than the bold colours and complex forms of Gothic art, meant that windows were deliberately removed and replaced by clear glazing. Hampp took advantage of this situation, and in 1802, after the Peace of Amiens, travelled to Rouen and Paris, where he 'filled seventeen great boxes'.[9] In 1803 he travelled to Aachen, Cologne and Nuremberg and filled ten more. These boxes contained no less than 284 items of stained glass which he offered for sale at Christie's in 1804, 1808, 1816 and 1820.[10] The content of these sales forms the basis of most of the world's private and museum collections of medieval stained glass to this day.

Sir George Jerningham's collection was one of the finest of its time, but in 1918, following his death, the estate was broken up. His 79 windows were catalogued by Maurice Drake[11] and sold by Grosvenor Thomas in September 1919.[12] Thomas (1858–1923) was an Australian-born artist, art collector and dealer who had settled in Glasgow around 1885. It was at

his house, 11 Crown Terrace, Glasgow, that he exhibited works of art and stained glass from Costessey Hall.[13] It is most likely that Burrell not only bought his selection of Costessey glass from Thomas at this time, but also that most of Burrell's stained glass bought prior to 1920 was also acquired through him.

Of the 18 windows that came from Costessey, 11 were bought around 1920, and the other seven were acquired in the 1930s and 1940s from other private collections. Two of the largest, and most important, windows that came from his original purchase through Thomas were the two-light *Tree of Jesse*, and the three-light *Life of St John the Evangelist*. Both these windows were described by Maurice Drake thus:

> . . . the showpiece of the [Costessey] collection, apart from the Jesse window, is the extraordinary window illustrating the life of St John the Evangelist. These lights occupied the upper part of the west window in the chapel at Costessey. They have now been reassembled and form a unique example of the best work done by French artists at the end of the 15th and beginning of the 16th century.[14]

The two-light *Tree of Jesse* (Fig 5) stems from a long tradition of visually representing the genealogy of Christ based on the prophesy from Isaiah 11:1:

> And there shall come forth a rod out of the stem of Jesse,
> and a Branch shall grow out of his roots:

Jesse, the father of King David, is usually shown in a recumbent, or sleeping, position at the base of the window. From his side grows a stylized tree on whose branches are placed various kings, prophets and patriarchs who surround the central figures of Christ and the Madonna. The Burrell window, as bought from Costessey, depicts part of a complete tree, the figures of Jesse, Christ and the Virgin having long since been lost. Of the figures themselves, only one is accurately identifiable, that of King David in the bottom left-hand corner, who is shown playing his harp. The window has been attributed to a church in Rouen, and dates from the beginning of the 16th century.[15]

The other window, showing three scenes from the life of *St John the Evangelist* (Fig 6), also comes from Rouen, from the destroyed church of St John, and likewise dates from the first quarter of the 16th century.[16] This three-light window is known to have been brought over by Hampp and sold at Christie's in 1808.[17] Originally the three scenes were part of a much larger eight-light series depicting various incidents in the life of St John the Evangelist. The remaining five lights are now in Wells

5 **Tree of Jesse** (45/393–4), *French (Rouen), early 16th century*

Cathedral. The story of St John the Evangelist is based on a 2nd-century apocryphal writing which is now partly lost. It was rewritten as part of a series of stories called *The Golden Legend*, compiled by Jacobus de Voragine (1230–98), who was Archbishop of Genoa in the late 13th century. His book gained much popularity, and greatly influenced medieval art and literature.

The three panels in the Burrell Collection illustrate St John surviving immersion in a cauldron of boiling oil, writing the Book of Revelation on the island of Patmos, and raising his friend Drusianna to life. There are many interesting incidental details in each of the panels. In the left-hand light, one of St John's executioners shields his face with his hands from the heat of the fire, while another fans the flames with his bellows. In the central light the Book of Revelation appears to St John through the clouds in a shaft of sunlight. Below the book the seven-headed dragon from

Revelation 12 appears on Earth with its ten horns and seven crowns. Below him is St John's apostolic symbol, the eagle, holding an inkpot in its beak.

At the bottom of each light are eight figures, kneeling in an act of prayer. They are members of the Bigar de la Londe family, who were influential in Rouen at the beginning of the 16th century:[18] left to right – Monsieur Bigar de la Londe, his two sons, his wife and four daughters. The practice of portraying the donor of the window appeared as early as the mid-12th century and became widespread throughout Europe in the 15th and 16th centuries, either in the form of a little figure or group of figures, as an inscription, or as an identifiable coat of arms. The reasons for donating a window were not always purely altruistic. In the *Creed of Piers Ploughman*, written shortly after 1384, a priest entreats the author to part with money for the good of his soul:

> And mightestou amenden us
> With moneye of thyn owen,
> Thou shouldest knely bifore Christ
> In compas of gold,
> In the wide window west-ward
> Wel neigh in the myddel
> And Saint Fraunceis himselfe
> Shal folden the in his cope,
> And present the to the Trinite
> And praye for thy synnes.[19]

It was not uncommon for donors to vie with each other to erect a window more splendid than their neighbour's, and for the figures themselves to become more dominant and centrally positioned, partly as a mark of their belief in their own importance, and partly out of a desire for the salvation of their souls (see also Figs 11, 41, 67 and 74).

Other windows bought by Burrell from Costessey are included in Appendix 2.

Shortly after World War I, Grosvenor Thomas was joined by Wilfred Drake (1879–1948), a founding member of the British Society of Master Glass Painters, and an expert in all matters relating to the restoration, craft and history of stained glass. Frederick Drake, his father, had a studio in Exeter where Wilfred and his brother Maurice were apprenticed to the trade. Maurice published many books and papers about stained glass,[20] including *A History of English Glass Painting* in 1912, which is still acclaimed as being one of the best books on the subject. Wilfred himself also wrote many articles and several books,[21] the two most notable being *A Dictionary of Glass Painters and Glasyers of the Tenth to the Eighteenth Centuries* which he compiled throughout his life and was

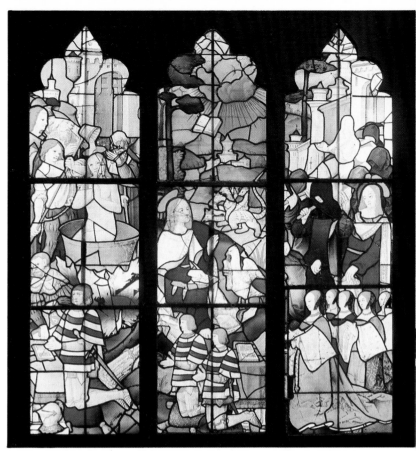

6 **Life of St John the Evangelist** *(45/390–2), French (Rouen – Church of St John),*
early 16th century

eventually finished by his niece, Daphne, in 1955, and *Saints and Their
Emblems* which was written jointly with Maurice. Wilfred became one of
the leading authorities on stained glass in Britain during the first half of
the 20th century. A strong business relationship and eventual friendship
was struck between him and Burrell, and a complete correspondence of
over 700 letters, spanning a period of 23 years between 1925 and Drake's
death in 1948, exists in the archives. Within these letters lie hidden
insights into both men, their love of stained glass, their acute business
acumen, and, most significantly, a wealth of invaluable information, both
technical and historical, about every window that passed through
Drake's workshop and into Burrell's collection. His respect for Drake is
clearly expressed in two letters written during World War II when many
buildings throughout the country were removing their valuable
windows and placing them in safe storage:

> ... having superintended the taking out of St George Chapel glass and being the only real expert of glass in Britain you should be overwhelmed with this class of work just now. (WB–WD, 22.1.41)

> I am so glad you are engaged on the glass of three churches – I always felt you should have been 'snowed under' with this class of work as no one else knows it nearly so well. (WB–WD, 27.9.44)

When Grosvenor Thomas died in 1923, his son, Roy Grosvenor Thomas, joined Drake in what was to be an extremely successful transatlantic partnership, with Thomas in New York and Drake in London. It was through these three men that most of Burrell's stained glass was bought. Other dealers and private individuals from whom Burrell bought his glass included Arnold Seligman, Jacques Seligman, John Hunt, M. R. Strora, F. Fabert, Bacri Frères, R. Lauder, Frank Surgey and Frank Partridge.

The last-named, in collaboration with Drake and Thomas in 1938–9, secured the purchase of 17 magnificent windows from William Randolph Hearst's collection (Appendix 3). Hearst's downfall was due partly to his unwillingness to keep his newspaper empire technologically ahead of his rivals and partly to his own overspending. Burrell's attitude to Hearst's extravagance is clear. In a letter to Drake dated 3 March 1939 he expressed his concern that the committee in New York which had been set up to sell off Hearst's treasures might expect too high a price for stained glass which in Burrell's opinion had been overpriced in the first place:

> ... musn't judge by what Hearst paid as he paid whatever was asked whether genuine or spurious ...

None the less, Burrell paid what he considered to be 'very full prices'[22] for the windows which, in Drake's opinion, made Burrell's stained glass 'the finest private collection in existence'.[23]

Included in the sale was the 13th-century medallion window of the *Marriage at Cana* (Fig 7), attributed to the Cathedral of Clermont-Ferrand.[24] It depicts a scene from the marriage feast at Cana which takes place either immediately prior to or following Christ's miracle of turning water into wine. It is very similar in style and composition to another feast scene panel which has been identified as originating from the St John the Baptist Chapel in the same cathedral, and which is now in the Memorial Art Gallery of the University of Rochester, NY, in America.[25] In the Burrell panel, the head of the feast sits at the centre of the table holding a golden goblet. He is turned to face the bridegroom on his right who raises one hand in a gesture of blessing while pointing downwards

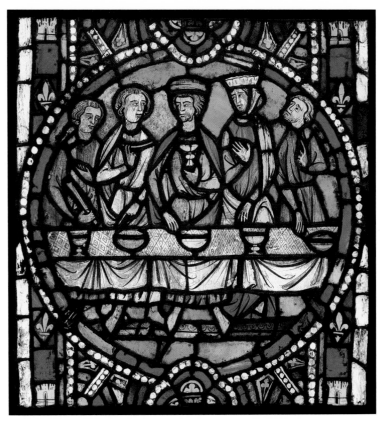

7 **Marriage at Cana** (45/366), *French (Clermont-Ferrand), 1275–85*

with his left hand, presumably to a scene taking place in a lower medallion. The bride, on the left side of the host, looks towards her husband with an expression of astonishment. Next to her a guest looks upwards, pointing either to heaven or to a scene taking place in an upper medallion. At the opposite end of the table another guest looks on. The two medallions above and below the central scene show one man standing beside a cooking pot and another pumping bellows to keep a cauldron hot. It is unlikely that this was the original layout of the three medallions, because when Burrell bought the window the upper and lower medallions were framed with the painted surface on the outside.[26] It is obvious from the backgrounds and border motifs that all three medallions belong together. A wide border of yellow fleur-de-lys and castles runs up and down the entire length of the window. These are the emblems of French royalty, and of Blanche of Castille (wife of Louis XIII and mother of Louis IX, St Louis) who was Queen of France between 1223 and 1236. However, these emblems were a common decorative motif in

the late 13th century and consequently cannot be used to date the window, which was probably made between 1275 and 1285.[27]

Perhaps the most extraordinary thing about this window is that virtually all of it (except the purple bellows in the lower medallion and one or two border pieces) is original. Even the lead has survived over 700 years, intact and unrestored, which is unusual for a window of its size and date.

Two of the largest windows in the collection, which Burrell also acquired from Hearst, are the *Life of Christ and the Virgin*, and *St Cunibert and a Bishop Saint*, both of which originate from the 14th-century Carmelite church at Boppard-am-Rhein just south of Cologne.[28] They date from 1440–6, having been installed shortly after the construction of the north nave in 1439. They formed part of a vast glazing programme of seven enormous windows, each one in praise of the Virgin Mary, whose Immaculate Conception the Carmelites had vigorously upheld at the Council of Basel in 1439.[29] Once again, political and social upheaval in Europe (this time due to the Napoleonic invasion of the Rhineland and the secularization of the monasteries) caused five of the windows to be removed in 1818 and replaced with plain glazing. They were packed and taken to Muskau in Lausitz to be installed in the private chapel of Count (later Prince) Pückler. Only one half-window was ever unpacked, the rest being sent to Berlin for restoration after the Prince's death.[30] It was during their time in Berlin that each window was given a letter and a number, which was painted on the inside surface of the glass with white paint (Fig 8). In the subsequent splitting up and distribution of the windows throughout Europe and America, these numbers have helped identify and place all the individual panels within their original scheme.[31]

The six panels with scenes from the *Life of Christ and the Virgin* (Fig 9) are part of a much larger window which depicted a particular type of Jesse Tree (Fig 10). In Germany during the 13th–15th centuries the Genealogy of Christ Tree was often replaced with a Life of Christ Tree, showing different scenes from His Nativity, Life and Passion. In Boppard these scenes surrounded the central focus of the window, that of the Life of the Virgin, thus emphasizing her immaculacy and her importance as

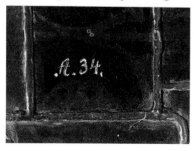

8 **A.34**
Detail of Boppard numbering system
from **Bishop Saint** *(45/487)*

9 **Life of Christ and the Virgin** *(45/485),*
German (Boppard-am-Rhein), 1440–6

10 **Photomontage reconstruction**
of Boppard Tree of Jesse
(Photograph courtesy of Dr Jane Hayward)

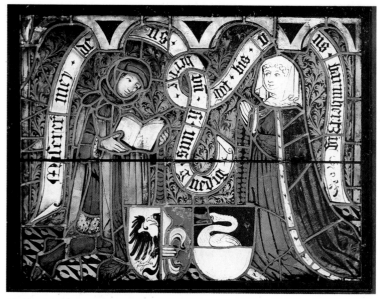

11 **Siegfried von Gelnhausen and his Wife** *(45/489),
German (Boppard-am-Rhein), 1440–6*

the mother of Christ.[32] The figure of Jesse, which is now in California,[33] occupied his usual position in the bottom of the window, as the recumbent root of the tree.

The donor figures connected with this window, *Siegfried von Gelnhausen and his Wife* (Fig 11), had another reason for wishing to be seen and recognized, not just for the sake of their souls, but also for political expediency – it was useful to show allegiance to the Carmelites in a region which was dominated by their influence.[34]

The other Boppard window from Hearst's collection shows two large saints standing under an elaborate canopy. They formed part of a much larger window containing six figures, two of which are now in collections in San Francisco and New York.[35] This was the last window of the series to be installed at Boppard, and can be dated by the inscription: *[begon] nen in dem Jahr da man zahlt MCCCC/XL, und in dem [Jahr] vollbracht [die] Fenster XLVI.*[36] (Begun in the year reckoned as 1440 and the window completed in the year 46.) One of the figures can be identified as *St Cunibert* (Fig 12), the patron saint of Cuno von Piermont who donated the window. The other figure is an *Unidentified Bishop Saint* (Fig 13), but could possibly be St Severinus, who was Archbishop of Cologne and patron saint of Boppard.[37]

In the following year, 1939, Burrell acquired another window from Boppard, this time from the collection of Robert Goelet in America. The *Ninth Commandment and Glorification of the Virgin* (Fig 14) window was the

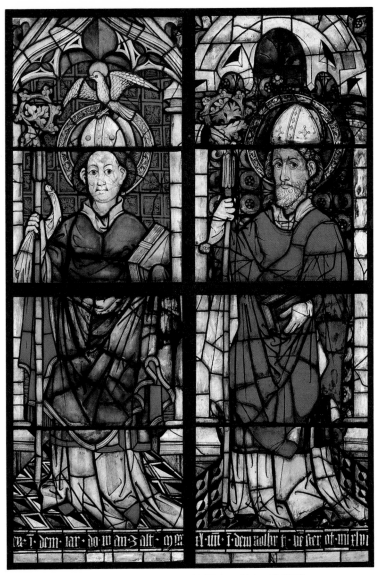

12 **St Cunibert** *(45/487),*
German (Boppard-am-Rhein), 1440–6

13 **Bishop Saint** *(45/487),*
German (Boppard-am-Rhein), 1440–6

most important in the entire glazing programme as it bore the arms of the
Emperor Albrecht II.[38] The iconography of the window is full of Marian
symbolism: she is portrayed as the New Eve, offering her fruit (an apple?)
to her Son, the New Adam. In the original window they were surrounded
by the Ten Commandments, thus linking the New Law of salvation with

the Old.[39] Even in the middle of such complicated imagery there is still scope for a little light relief: in the *Ninth Commandment* panel underneath the Virgin, two groups of four people stand next to each other, under the watchful demi-figure of God. The pious on the right kneel and pray and appear to have gained God's approval, while those who bear false witness on the left point accusingly at their neighbours, to the obvious delight of a very perky devil who floats in mid-air above their heads (Fig 15).

The importance of the Boppard windows cannot be overemphasized, not only because of their sheer scale and beauty, but also because of their survival as an important iconographical scheme based on the cult of the Virgin Mary. Similar windows were often smashed or totally destroyed during the periods of religious intolerance and war that swept across Europe.

Three years after the Hearst sale, Burrell expressed his frustration about the economic situation in which he found himself because of World War II:

> These are most difficult times financially for everyone, even the richest, who get 19/6 per £ taken from them so that they require £200 income if they wish to give a friend a £5 note! And I naturally don't wish to encroach too far on my Capital for that is the only way in which one can buy anything just now. (WB–WD, 29.1.42)

Throughout the entire duration of the war he only bought 54 windows. However, considering the tremendous buying and shipping restrictions of the times it must be considered as no mean achievement. The Goelet window was first seen by Drake on a visit to New York on 25 May 1938 and recommended to Burrell the following year.[40] The financial transactions involved in securing its purchase took exactly six months, from 21 November 1939 until 21 May 1940. The problems began on 26 December, when Roy Grosvenor Thomas, Drake's partner in New York, sent him a telegram following Goelet's agreement to sell:

PLEASE PAY GOELETS BANK ONE THOUSAND POUNDS.

Drake promptly sent a cheque to the manager of Barclays Bank, Piccadilly, with a covering letter explaining what was being bought, by whom, and from where.[41] The transaction was refused by the Foreign Exchange Control of the Bank of England who wanted to know:

> When was the sale of this window executed and arrangements for its removal completed. Can any documentary evidence be submitted to support this transaction. What is the nationality of Mr R. G. Thomas. What is the ultimate destination of the window.[42]

14 Ninth Commandment and
Glorification of the Virgin *(45/487),·*
German (Boppard-am-Rhein), 1440–6

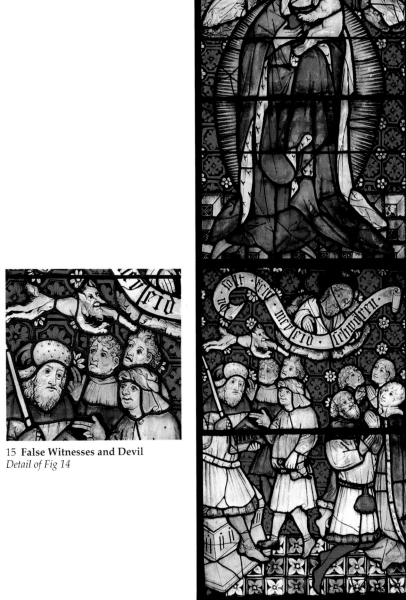

15 False Witnesses and Devil
Detail of Fig 14

After further lengthy negotiations payment was still not authorized. On 2 February the problem was further complicated when Drake received an official letter from HM Prison, Wormwood Scrubs (the address of the War Office Controller of Postal & Telegraph Censorship):

Sir,

The attention of the Controller of Postal & Telegraph Censorship has been drawn to a cable sent to you by 'Thomas', New York, on December last . . . In view of the possible bearing of the Defence Financial Regulations upon this communication, I am to request that you will be good enough to explain the transaction to which it refers . . .

I am, your obedient Servant,
Deputy Financial Advisor

Drake sent his reply on 5 February:

Sir,

In answer to your letter 114 of Feb 2 regarding a cable sent to me from New York.

I am a fine art dealer (and member of the British Antique Dealers' Association) of British nationality.

'Thomas' is Mr R. G. Thomas, British nationality, residing in New York (38 East 57th Street) a fine art dealer, and my partner.

'Goelet', is Mr Robert Goelet, a wealthy American gentleman, who resides at 608 Fifth Avenue, New York, and at Newport, Rhode Island. He is a well-known member of American society (not a fine art dealer) and has a banking account with Barclays Bank, Piccadilly, W1.

The 'one thousand pounds' was to have been my payment, to Mr Goelet, for the purchase of an ancient stained glass window (from his private collection) which I wished to acquire.

The Bank of England under the new Foreign Control Regulations have declined to allow me to pay the money into Mr Goelet's account at Barclays, so the transfer will have to be cancelled.

Yours faithfully,
W. Drake

Permission was finally given by the Bank of England at the end of March, to allow Burrell to pay for the window directly, from his own bank account, although the window remained in New York until the end of the war.[43]

Because of his reluctance to overspend in such financially trying times, he sometimes failed to buy glass that would have made a fine addition to

16 **Twenty heraldic panels from Vale Royal Abbey, Cheshire**

the collection, such as the 16th-century Cologne panels from Ashridge House in Hertfordshire which went instead to the Victoria and Albert Museum collection.[44]

More often than not his Scottish canniness paid off. In August 1947 he acquired 38 heraldic panels from Vale Royal Abbey (Fig 16) in Cheshire for a mere £55. The abbey was built in 1277 but partially destroyed during the dissolution of the monasteries in the mid-16th century. It was later rebuilt into a stately home by a local landowner, Thomas Holcroft, from whose estate it was sold, in 1616, to the Cholmondeley family. Not all of the glass originates from Vale Royal, but was collected piecemeal from the gradual break-up of various stately homes (including Utkinton and Spurstow Halls). Depicted on the glass are the coats of arms of the landed gentry of Cheshire, and various royal shields and badges.[45] In 1755, 11 of them were recorded as being in Tarporley Rectory, Cheshire, by the Reverend William Cole, who was forced to convalesce there after breaking his leg falling from a horse.[46]

Burrell enthused to Drake about the Vale Royal glass:

> . . . I realise more than ever what a wonderful lot we got, what a bargain. (WB–WD, 14.4.47)

What must surely be his most remarkable bargain was a little panel of a bearded saint which he bought from Arnold Seligman in 1923 for £114 5s 10d. It is unlikely that Burrell himself knew what a priceless panel he had, for it is simply described by Drake as:

> Panel. Male figure bearded, probably a prophet . . . French XIII century.[47]

It was not until 1961, three years after Burrell's death, that the bearded

23

saint was identified by Professor Hans Wentzel, an expert on German stained glass, as the *Prophet Jeremiah* (Fig 17), a lost panel from the *Infancy of Christ* window in the Abbey Church of St-Denis on the outskirts of Paris.[48] His identification was confirmed shortly after by Louis Grodecki, the recognized expert on the glass at St-Denis.[49]

The figure was identified by the Latin inscription on the phylactery held in his hands – *Novum faciet dominus super terram: femina circumdabit virum* (The Lord hath created a new thing in the earth, a woman shall compass a man) – which is a quotation from Jeremiah 31:22, prophesying the birth of Christ. Originally he would have been placed at the bottom right-hand corner of the window. Adjacent to him would have been a panel depicting the Annunciation, which remains in situ at St-Denis although now very heavily restored. Opposite *Jeremiah*, at the bottom left-hand corner, would have been a figure of Isaiah, inscribed ECCE VIRGO (Behold the Virgin, from Isaiah 7:14). The 16th-century restored copy of Isaiah was identified as recently as 1986–7 in Lord Barnard's collection at Raby Castle.[50]

The history and iconography of the windows at St-Denis have been well documented, as it was one of the first buildings in Europe to adopt the new Gothic style of architecture in the 12th century. The abbey suffered badly during the French Revolution, having been the burial place for the French royal family. In 1799 the windows were removed to safety by the historian Alexander Lenoir and stored in his Musée des Monuments Français. The windows were returned to St-Denis in 1820, where *Jeremiah* was drawn in store around 1850 by the architect Jean Just Lisch. The extent of restoration on the Burrell panel is evident when compared with Lisch's drawing. The bases, columns, capitals, architrave, stars, quatrefoils and most of the ruby background were added in the late 19th century, based on a previous drawing done in 1794–5 by the architect, Charles Percier. However, the original 12th-century glass in the panel, which makes up the figure of Jeremiah, most of the inscription (except the letters FEMINA CIRCU), and the ruby glass immediately surrounding him, is of the highest quality, with little sign of corrosion or loss of paint.

Jeremiah was never reinstalled at St-Denis, but was eventually sold to Arnold Seligman, a Parisian antiquarian, around 1900. Seligman subsequently sold the panel to Burrell in 1923, by which time its true identity and historical importance had been lost or forgotten.

The *Infancy of Christ* window that now exists in St-Denis is an iconographical jumble of fragments from the original *Infancy* and *Life of the Virgin* windows, which were combined in a massive restoration programme devised by the architect Viollet-le-Duc between 1846 and 1879. Glass not used in the 19th-century restorations has since been scattered throughout Europe and America.

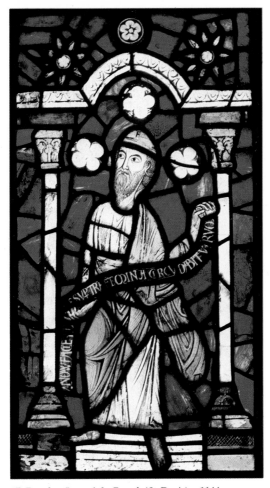

17 **Prophet Jeremiah,** *French (St-Denis), c.1144*

It was French and English glass which gave Sir William the most pleasure. In 1932 he wrote:

> I am fired with the idea of having only English and French glass – as much English as possible. (WB–WD, 17.9.32)

Of the 706 windows that are presently in the collection, over 335 of them are English. They span a period of over 700 years, from the 12th to the 19th centuries, the majority of which are heraldic coats of arms. The earliest heraldic glass dates from the 14th century of which there are some splendid examples. The *Arms of Somery* (Fig 18) is one of the finest,

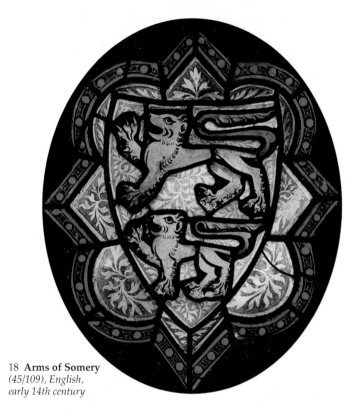

18 **Arms of Somery**
(45/109), English,
early 14th century

and depicts the shield of the Somery family who were the Barons of
Dudley from 1194 until 1322.[51] Shields in the 14th century were fairly
simple, often only bearing the arms of a knight, or a knight and his wife,
in which instance the shield would be divided vertically into two halves,
the left (sinister) half bearing the arms of the husband, and the right
(dexter) half bearing those of his wife. Each horizontal and vertical
division is known as a quartering, although the number of quarterings in
a shield are frequently many more than four. As more families were
granted coats of arms, the divisions in the shields became more and more
complicated due to the desire of each family to prove their pedigree by
displaying as many of their ancestors' arms as possible. In the 15th and
16th centuries new techniques were developed which allowed glass
painters to represent many tiny quarterings within each shield. On the
whole, Burrell considered the 16th century rather late for his taste.[52]
However, he did have one weakness for the art from that century. In 1939
he told Drake that he was:

 . . . not attracted by 16th-century glass unless English armorial.
(WB–WD, 16.12.39)

19 **Armorial panel –**
Sir Edmund Knightley
and Ursula de Vere
(45/332) English (Fawsley Hall),
mid-16th century

In 1941 he added:

> Only 16th-century glass I care for is armorial English glass. Has not only colour, but is English, and being armorial intensely interesting. (WB–WD, 21.2.41)

One of the most interesting, and certainly the most complete series of mid-16th-century English heraldic glass comes from the Great Oriel window in Fawsley Hall, just south of Daventry. In 1939, on Drake's advice, Burrell offered Lord Gage (the then owner of Fawsley Hall) £700 for the armorials. His offer was rejected, and it took another 11 years of negotiations before the windows were eventually sold to him for £2000 in 1950.[53] The 39 panels, most of which are in excellent condition with little sign of restoration or re-leading, bear the arms of the Knightley family, and illustrate their links with royalty and other politically important families.

The largest panel depicts the marriage of *Sir Edmund Knightley and Ursula de Vere* (Fig 19). It consists of a central shield divided vertically into two halves: the sinister side bearing the 24 quarterings of Sir

27

Edmund's paternal and maternal ancestors and the dexter side bearing those of his wife. Above the splendid helmet and mantling is the stag's head of the Knightleys. Supporting the shield is the golden falcon of the Skenards (Sir Edmund's mother's maiden name) and the blue boar with a yellow star (mullet) of the de Vere family.[54] The panel itself has been partially restored and altered in size (both the boar and the falcon are lacking part of their hindquarters, and some of the mantling at the top is also missing). Sir Edmund undertook the completion of the Hall between 1537 and 1542 and his coat of arms would have been given pride of place beside their ancestors who can be traced back to the 11th century. The coats of arms of each of the families are easily identifiable: the Knightleys being square, and slightly rounded at each corner, and the de Veres being completely round.

On the painted background of one of the roundels, *de Vere Impaling Hume* (Fig 20), is inscribed the signature of an otherwise unknown artist: 'W. Butlim, DAVENTRY, Painter' (Fig 21). (His name does not appear in Maurice Drake's *Dictionary of Glass Painters and Glasyers*, nor on any other window in the series.) The proximity of Daventry to Fawsley Hall (approximately 4 miles), gives weight to the evidence that he was probably involved in the earlier glazing programme of 1537–42.

A second series of six armorials was added, probably between 1566 and 1580, by Sir Edmund's nephew, Sir Richard Knightley. They are much more elaborate in shape and quite different in technique to the earlier panels, and their relationship to each other in terms of political intrigue is fascinating. Sir Edmund Knightley died in 1542. His six daughters were not eligible to inherit the estate, which passed on to his younger brother, Valentine Knightley. Sir Valentine died in 1566 and was succeeded by his son Sir Richard Knightley who was married twice: first to Mary Fermore, and second to Elizabeth Seymour, daughter of Edward Seymour, Duke of Somerset. Edward Seymour was the brother of Jane Seymour, third wife of Henry VIII (Fig 22), and uncle of the young Edward VI during whose minority he served as Protector of England. His great rival and enemy was John Dudley, the Duke of Northumberland, who had him executed in February 1552.[55] Curiously, his eldest daughter, Anne, married Dudley's second son, John, in what must have been an extremely tense relationship! The shield of John Dudley's younger brother, Ambrose, is part of the series, as is that of William Parr, brother of Catherine Parr, sixth wife of Henry VIII. After the death of Henry VIII in 1547, she married Thomas Seymour, the brother of Edward and Jane. The last armorial in the series belongs to the marriage of Sir Edmund Knightley's sister, Susan, to Sir William Spencer of Althorpe.

Another popular form of heraldry in the 15th and 16th centuries was that of the badge or motto. This took the form of a visual pun or play on words, or a contrived visual illustration of an actual, or suspected,

20
de Vere Impaling Hume
(45/331), English
(Fawsley Hall),
mid-16th century

21 **W. Butlim,
Daventry,
Painter**
Detail of Fig 20

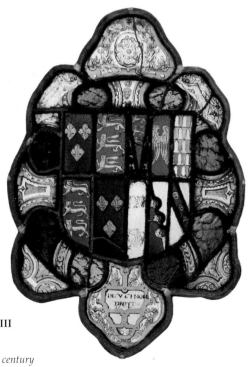

22 **Arms of Henry VIII
and Jane Seymour**
(45/318), English,
Fawsley Hall, late 16th century

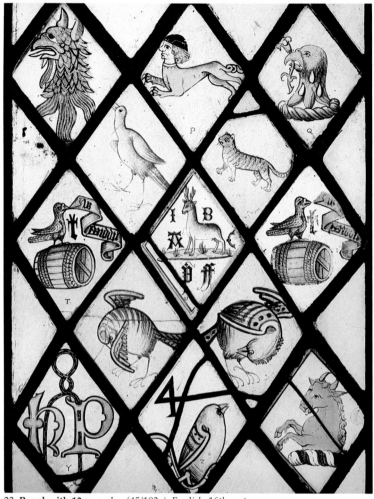

23 **Panel with 13 quarries** *(45/102a), English, 16th century*

incident in the life of a person. Often they were quite small, diamond-shaped, and were frequently used to fill up the space in a leaded window around a larger, more colourful shield. Fig 23 shows 13 such quarries from different sources which have been leaded together. An alphabetical letter has been painted at the bottom of each quarry, which have been identified, from top left to bottom right, as follows: '(o) a griffin's head erased; (p) a running man-headed tiger; (q) an eagle's head guttee de larmes erased holding a flower sprig in its beak, said to be for Walcot; (r) a stork; (s) a panther passant, perhaps for Henry VI; (t) rebus of William Middleton, a bird perched on a barrel with inscribed scroll: W. Middil-t-un, and the black letter T between; (u) a stag statant surrounded by the letters A. I. B. C. ff. and p., said to be the rebus of Buckland; (v) similar to

(t) above; (w) and (x) two birds; (y) the initials h. and p. joined by a chain; (z) bird and merchant's mark; (zz) a demi-bull, rampant or, said to be for Bulmer.'[56] In a companion panel (Fig 24) there is an interesting quarry which shows an incident in the *Funeral of Reynard the Fox*, who is seen recovering from a deep faint which had been mistaken for death by the pall-bearers. The story of wily Reynard was extremely popular in medieval art, and can be found in most of the contemporary arts of the period.[57]

An illustration that is a visual pun is known as a rebus. One of the best examples

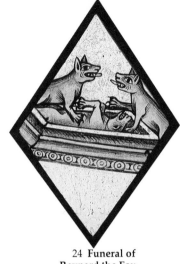

24 **Funeral of Reynard the Fox** *(45/102b (d)), English, 16th century*

25 **Rebus of John Islip** *(45/223), English, 16th century*

31

in the Collection is the *Rebus of John Islip* (Fig 25), Abbot of Westminster during the first quarter of the 16th century. His rebus is a play on his name, Islip, and shows a boy precariously perched up a tree, with an eye and the letters SLIP underneath.

By far the most common English figurative glass owned by Burrell comes from Norfolk. The charming, delicately painted figures with expressive faces which characterize the Norfolk School of glass painting in the 15th century were much loved by Burrell. They indicate his fondness for incidental details rather than just a purely academic interest in stained glass. In them can be seen all aspects of English life in the late Middle Ages: costume, domestic interiors, feasts, festivals, faith and food. Their use was not restricted to churches: they were commonly made for houses, colleges, guild-halls etc. Such was the skill of the glass painters that they happily worked on small roundels or quarries if cost restricted the type of window that could be made. However, a reduction in size did not mean the diminution of quality or attention to detail.

A popular theme used by the Norfolk glass painters (and many others throughout Europe in the 15th and 16th centuries) was the Labours of the Months: a series of 12 panels depicting the customs and working practices which were carried out by the local population at different times of the year. The particular images used were very much dependent upon the whims of the artist, with the same images being used to represent two or more different months. Christopher Woodforde, in his book *The Norwich School of Glass Painting in the Fifteenth Century*, describes them thus:

January:	feasting, keeping warm by the fire
February:	keeping warm by the fire, pruning vines, labourers digging, man and woman going to market
March:	pruning vines, digging in the vineyard (and picking fruit), sowing
April:	youths and maidens with flowers and garlands in gardens and meadows, hawking, hunting
May:	hawking, carrying trees or boughs, youth and maiden riding/walking/with musical instruments/with flowers/talking, crowned man with sceptre in thicket
June:	mowing, shearing sheep, carrying a sheep
July:	reaping, mowing
August:	threshing, reaping
September:	treading grapes, gathering grapes, sowing/ harrowing/hoeing/ploughing, beating oats for pigs
October:	treading grapes, pouring grape juice into barrel, sowing, beating oats for pigs
November:	beating oats for pigs, watching pigs feed, killing pigs
December:	killing pigs, baking bread, feasting.[58]

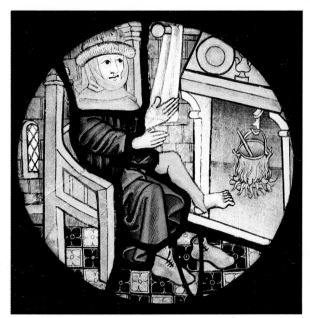

26
**Labour of the Month –
February** *(45/83),
English
(Norwich School),
15th century*

The delightful roundel of a little man warming his feet by the fire is mentioned in Woodforde's book as representing *February*[59] (Fig 26), and is part of a series which is thought to have come from the church of St Michael-at-Coslany in Norwich. September, October and November from the same series are in the Victoria and Albert Museum.[60]

Angels were another popular subject and the Norfolk glass painters took great pleasure in portraying them: covered with feathers, with elaborate wings, clothed in contemporary costume, with huge hats, with glittering tiaras, playing trumpets, pipes, bagpipes, harps, holding scales, flowers, books, boxes, shields, inscriptions, standing on their own, in a host, standing on wheels, flying in the clouds, situated in the tracery lights, main lights or small side lights of churches.

This passion for angels developed from *The Golden Legend* and other apocryphal writings, as well as the Bible itself. To the medieval mind angels were the guardians of the people; they bore their souls to heaven, supplicated on their behalf before God, and continued praising Him long after the liturgy had ended. They were arranged in a strictly ordered hierarchy, with each angel, or heavenly being, given a particular purpose and personality. The unique way of dressing them has been attributed to direct inspiration from the medieval mystery plays.[61] Although this must be taken as a vague generality, in the figure of the *Trumpeting Angel* (Fig 27) this would appear to be the case, as his feathers form part of an elaborate costume with leggings and sleeves, a skirt, a yoked collar and a large hat.

That so many of the angels are shown in a gesture of praise or playing musical instruments is a direct reference to Psalm 150: 3–5:

> Praise him with the sound of the trumpet;
> praise him with the psaltry and the harp.
> Praise him with the timbrel and dance;
> praise him with stringed instruments and organs.
> Praise him upon the loud cymbals;
> praise him upon the high-sounding cymbals.

The Golden Legend and the miracle plays also provided the inspiration behind the *Conversion of the Jew* panel (Fig 28) which came from the church of St Peter Mancroft in Norwich. The church, rebuilt around 1455,

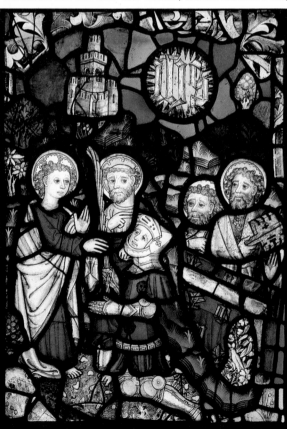

27
Trumpeting Angel *(45/84), English (Norwich School), 15th century*

28
Conversion of the Jew *(45/92), English (Norwich School), 15th century*

was glazed with a large east window which contained scenes from the lives of Christ and the Virgin. The panel illustrates an incident during the funeral of the Virgin when a prince of the priests laid hold of the coffin to stop its procession. His hands became miraculously stuck to the bier, and caused him much pain when he tried to get free. On crying out for help, St Peter handed him a heavenly palm branch and demanded his conversion, which he promised, and the procession was able to continue. The windows of St Peter Mancroft suffered badly during the 17th century when a parliamentary gunpowder plot accidentally blew up a nearby house, and

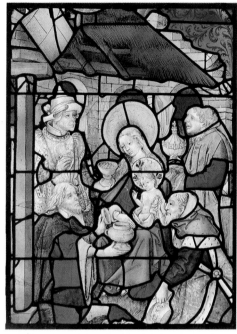

29 **Adoration of the Magi** *(45/427), German (Cologne School), 15th century*

consequent restorations and repairs have resulted in many of the original panels being lost or in private collections.[62]

Alongside the English and French glass, the other great strengths of the collection come from the pre-16th-century glass-painting schools of Flanders, the Rhineland and Cologne. Inspired by 15th-century Dutch art these glass painters produced their own form of pictorial realism which resulted in less stylized architecture, greater accuracy in perspective, and wonderfully comic gestures and expressions. The craftsmen of Cologne were particularly skilled in this last art, paying attention to the minutest of details. A group of windows illustrating scenes from the life of Christ provide an interesting insight into the costume, customs and buildings of the period.

In the *Adoration of the Magi* (Fig 29) Joseph is seen kneeling at the bottom left-hand corner while the three kings offer their gifts to the infant Christ who is seated on His mother's lap. The *Miracle at Cana* (Fig 30) shows Christ in deep concentration as He turns water into wine. The guests appear to be deep in conversation, either remarking on what is happening, or on the dead animal which has been provided on a plate for the 'feast'. Two trumpeters play in the background, the one on the left looking disconsolately at his neighbour. *The Ascension* (Fig 31) shows Christ, surrounded by His grieving mother and disciples, ascending to

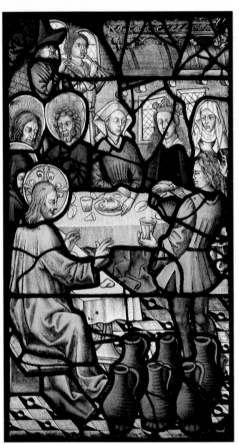

30 **Miracle at Cana** *(45/426),*
German (Cologne School), 15th century

heaven. Unfortunately the top section of the window, which would probably have contained clouds, angels and the heavenly host, has been missing since before it was installed at Costessey, and what remains is an amusing spectacle of a pair of feet set against a very elaborate background of red and gold quarries.

The Rhenish glass painters were not only fond of humour, but were capable of painting the most charming figures, such as *St Cecilia and the Angels* (Fig 32). She stands in her house which she has converted into a place of worship, and is surrounded by six angels with brightly coloured wings, who serenade the patron saint of music on contemporary musical instruments.

The influence of the Flemish glass painters stretched far beyond the frontiers of their country. They often worked abroad, including England and France. They were particularly influential in Rouen at the beginning of the 16th century due, in part, to the settling there of one man, Arnoult de Nijmegue, between 1500 and 1512. The *Life of St John the Evangelist* (Fig 6) is reputed to have been painted by one of his best students.[63] It came from the church of St John, which was under the joint patronage of St John the Evangelist and St John the Baptist. In the Collection is an eight-light window from the same church, illustrating scenes from the *Life of St John the Baptist* (Fig 33): the vision of Zacharias, the visitation, the birth of St John, St John taking leave of his parents, St John baptizing in the Jordan, St John rebuking Herod, Salome dancing before Herod, and St John's beheading at the instigation of Salome and the vindictive Herodias. Along the base of three of the lower lights an unidentifiable Rouen merchant donor kneels, accompanied by his wife, their son and daughter-in-law and their five grandchildren – three boys

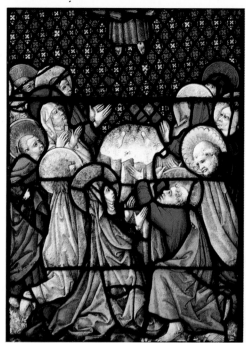

31 **The Ascension** *(45/433),*
German (Cologne School), 15th century

and two girls. Apart from the
artistic excellence of these
lights, there are many genre
details which have obviously
been taken direct from daily
life. There is good attention to
detail in depicting the
peculiarities of 16th-century
French costume – one of the
men being baptized has left
his boots by the side of the
river. Wildlife is also well
drawn, and includes various
birds, two dogs, a cat and a
rabbit (Fig 34).

Swiss miniature
masterpieces from the 16th
and 17th centuries are also
well represented in the
Collection (Fig 35). Made
primarily for a secular market
for the merchant classes, these
little panels contain all the
colour and detail of 'ordinary'
windows, but at a fraction of
the usual size.[64] Often the
man, guild, or borough
commissioning such a panel
would ask that some reference
be made to his trade, their
profession, or their town, with
additional references being
made to a particular patron
saint. If no official coat of arms
had been granted it was not
unusual for the artist simply to
make one up. These panels
were hung or glazed into plain

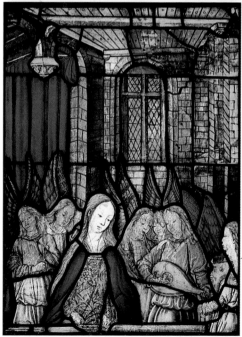

32 **St Cecilia and the Angels**
(45/377), German (Rhineland),
15th century

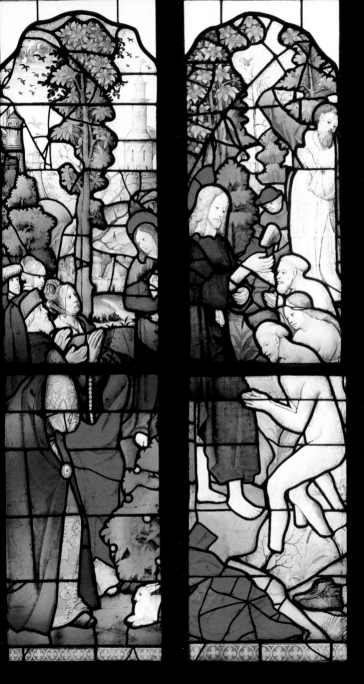

windows as a popular form of self-advertisement. Among the panels which Burrell is known to have owned at the end of the 19th century are two small Swiss roundels,[65] one of which depicts *St Notker Nobulus* resisting temptation by the devil who appears in the form of a dog. The other, dated 1671, depicts two scenes from the life of *St Francis* (Fig 36). During its conservation in 1978 it was revealed that it had been painted by Michael Müller IV, a prolific glass painter from an important family of 16th- and 17th-century glass painters from the town of Zug, in Switzerland.[66] At the very bottom of the roundel, in between the two shields, there is a fragment of a letter M, the artist's signature. In a notebook written by Müller, now in Zug Museum, there is a copy of a poem which describes various incidents in the life of St Francis (stanza 3):

> In pilgrim's guise an angel came
> from heaven who picked up the child,
> predicted how the devil soon
> would molest him with all his might.[67]

These lines are written in Swiss-German in the yellow band across the centre of the panel, and are illustrated above it on the right. On the left a later scene in St Francis's life takes place: trapped in a tower outside a city, he is the subject of the plotting going on underground by some particularly vicious-looking devils. The execution of the enamel and paintwork is of the highest quality, and a truly outstanding example of Swiss craftsmanship.

As for the Dutch glass in the Collection Burrell considered it 'rather a blot than otherwise'[68] and had to be continually reassured by Drake that it was good enough for his Collection.[69] Despite this there are over 30 Dutch windows in the Collection.

There are a few examples of glass in the Collection which are post-16th century. Most of these are fragments from Dutch, German and Swiss

33 **Life of St John the Baptist**
(45/417–24),
French (Rouen – Church of St John),
early 16th century

34 **Rabbit** *Detail of Fig 36*

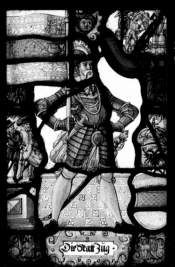

35 Swiss Soldier with the Arms of Zug
(45/510), Swiss, 1605

Die Statt Zug

36 Scenes from the Life of St Francis
(45/530),
Swiss, 1671

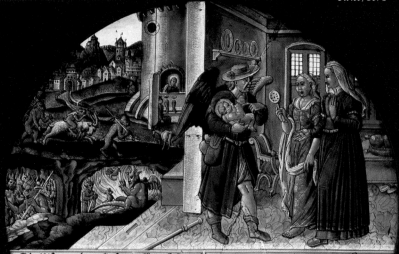

In Pilgrambs gstalt ein Engel kam
Von Himell der daß kindt auff nam

dagt vor: wie ihm der teuffel baldt
Zu setzen werd mit gantzem gwaldt.

Herr Wolffgang
alt Seckelmeister
Zug Fr.Maria
Schlümpf-
gmach

Keiser des Raths
der Statt Vnd Ambt
Magdalena
in sein Ehe-

**37 King Edward I
Vowing to the Virgin**
(45/103),
English (Vale Royal),
c.1800

**38 Dedication of
Vale Royal Abbey**
(45/104),
English (Vale Royal),
c.1800

windows depicting allegorical and genre scenes or fantastic birds, fruit and flowers. There are, however, three unusual exceptions. Along with the 16th-century Vale Royal glass which he bought in 1947 (Fig 16), he acquired two intricately painted panels illustrating *King Edward I Vowing to the Virgin* (Fig 37) that he would found an abbey at Vale Royal if she delivered him safely from a storm at sea, and the consequent *Dedication of Vale Royal Abbey* (Fig 38). Both panels date from around 1800, and are possibly copies of a medieval illustration, or fresco painting. Despite an unfortunate number of unsightly repair leads, the quality of the paint and enamel work is outstanding, especially in the ornamental borders of lion's heads, fruit and flowers. Of these panels he wrote:

> . . . I agree with you [Drake] that although two of the panels are about 1800, they should, on account of their interest . . . record[ing] the formation of the Monastery, be kept with the collection. (WB–WD, 18.2.47)

The other exception is an unusual, late 19th-century glass painting of the *Lady of Shalott* (Fig 39). Burrell's comments about this panel are revealing, not only in his liking for the work of the painter, Matthew Maris, and his knowledge of the contemporary art world, but also in his attachment to certain pieces of stained glass from a purely sentimental point of view:

> . . . a modern panel by [Daniel] Cottier representing one of Matthew Maris' pictures. I am a great admirer of Matthew Maris' work, and it was for that reason that I bought the panel many years ago.
> Maris was a 'dream' painter, not much appreciated in England, but I have about 40 of his paintings and drawings. He worked for Cottier for a time, and that is no doubt the reason why the panel came to be painted. He must have been very hard up when he worked there and the work must have been very uncongenial to him. They had a furious quarrel almost ending in bloodshed . . . I know as glass it is nothing, but I have a 'sentiment' for it. (WB–WD, 30.10.41)

Drake, in his reply, mentions that '. . . in 1872 Matthew Maris accepted the post of designer in stained glass which the decorator Daniel Cottier offered him in London . . . Your panel was, I suppose, painted by Maris himself.'[70] His hypothesis is most likely as the heavy painterly style is akin to Maris's, as can be seen in an oil painting of the same subject (Fig 40), and quite unlike the delicate line-work and intricately painted draperies of Cottier's windows. The ochre and olive colours, however, are typical of Cottier's studio.

39 **Lady of Shalott** *Matthew Maris (45/561),*
English/Dutch, late 19th century

40 **Lady of Shalott**
Matthew Maris (35/352),
late 19th century

In 1916 Burrell bought Hutton Castle in Berwickshire, a late 15th-/
early 16th-century building which was the ideal setting for his rapidly
growing collection of late medieval works of art. Alterations had to be
made, not only to allow Burrell and his wife and daughter to live
comfortably in it, but also to enlarge and alter the window openings to
allow the largest windows such as the *Tree of Jesse* (Fig 5) and *Life of
St John the Evangelist* (Fig 6) windows from Costessey to be installed.
Surprisingly, he appears to have had no qualms about allowing Drake to
rearrange or alter the size or shape of his stained glass to fit into
particular window openings as the following quotations from his
correspondence show:

> . . . sending you 10 pieces . . . should be turned into 5 pairs . . . (WB–
> WD, 15.7.28)
>
> . . . cheque for altering and repairing . . . (WB–WD, 3.9.28)
>
> . . . please keep as you spoke of altering two pieces in it . . . (WB–
> WD, 2.4.30)

... I am glad that you have secured some blue glass & that you are making up the Sotheby panel with them ... (WB–WD, 16.7.30)

... It is very kind of you to ... alter any of the other windows and I shall be writing to you about one or two soon ... (WB–WD, 14.4.41)

... am sending you 22 windows ... should like them *all* to be made oval ... (WB–WD, 24.6.41)

... One too broad for window – please decrease its size ... (WB–WD, 30.7.41)

... note sizes of lancet window that you are now cutting it into smaller sections ... (WB–WD, 29.8.42)

... note that you are cutting St George panel at *ink* line ... (WB–WD, 21.5.45)

By the end of 1929 all the stained glass purchased to date had been installed in the castle, and Drake was asked to make an inventory.[71]

What resulted is an intriguing list of 94 pages, dated 1932, listing 250 separate stained glass windows.[72] There was stained glass everywhere: in the dining room, drawing room and hall, in the lavatories, the bedrooms, the housemaids' pantries, the billiard room, the corridors, the attic, the staircases; it would seem from the list that no room was spared!

It was on the staircase leading up to his bedroom that Sir William eventually decided to place one of his favourite windows: *Beatrix van Valkenburg* (Fig 41), third wife of Richard, Earl of Cornwall, King of the Holy Roman Empire. Dated *c*.1270–80, she is now the earliest surviving donor figure in English glass, and is thought to have originally come from the church of the Minorite Friars in Oxford.[73] It was her connection with Hutton Castle that particularly pleased Burrell:

The position is even more interesting than before. Edward I slept in Hutton Castle in 1296 the night before he attacked and took Berwick-on-Tweed. He slept in the Tower Bedroom and as it was the only bedroom in the 'Keep' you may be sure that his cousin, Richard Plantagenet – Beatrix de Falkenburgh's [*sic*] stepson – slept in the same room so that the position is much closer even than the fact that Richard was killed at the siege of Berwick. The little panel is today only a few feet away from the bedroom in which her stepson no doubt slept.

The Keep was made up as follows:

Bedroom

Eating and Living Room

Cattle

It is well known that Edward I slept in that bedroom on the night in question. I think it is almost certain that his cousin (Beatrix's

stepson) – being of Royal blood – would be accommodated there as well. The account states that while the King slept in his Castle his army lay in the glade . . . the surrounding fields. (WB–WD, 27.7.36)

In his reply, Drake writes:

I can hardly think of anything more romantic than Richard Plantagenet the stepson of Beatrix sleeping at Hutton so near the window where she is now. (WD–WB, 5.8.36)

I hope that the Princess Cecilia [Fig 74] will be in a small window by herself one day; to 'balance' Queen Beatrix: a pair of English Royal portraits of different periods but each of them a fine example and full of romantic interest. (WD–WB, 9.6.39)

On 9 July 1941 Sir William wrote to Drake to suggest that stained glass might also be used in the summerhouse:

41 **Beatrix van Valkenburg** *(45/2), English (Oxford), late 13th century*

I think you may remember we have a little summer house in the garden. Now I have received from my house in Glasgow a good deal of glass – Dutch + therefore very moderate in quality – but I think some of it might be utilized in putting into the top of the summer house . . . do you think glass would help in the summer house? Perhaps it might be out of place?

At the bottom of the letter is a little sketch outlining Burrell's ideas. What is extraordinary is that they went ahead with installing the glass in the summerhouse at a time when nightly air-raids overhead were a common occurrence.[74] In a letter written during the previous year Burrell expressed his concern that:

. . . if the Germans come in numbers they will [not] avoid damaging the castle. (WB–WD,16.7.40)

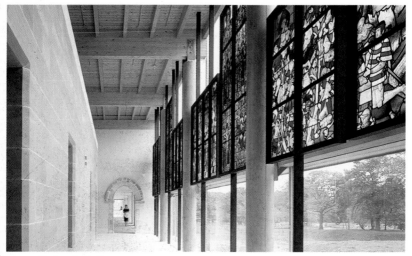

42 **South Gallery**

Four days later: 'Bombs [were] dropped on Berwick and three other places near us.'

From the correspondence it is clear that the summerhouse glass made frequent trips across the border to be repaired by Drake due to some of the panels continually falling down or being blown out by the wind.[75]

Fortunately Hutton Castle was not hit during the war, although all the stained glass was eventually removed from the openings and safely stored.[76] Sir William complained that 'Hutton looks very empty without its glass' and that he 'hope[s] to start soon putting glass back into Hutton windows'. (WB–WD, 18.1.46)

This he did, and there it remained until just before his death in 1958. In 1956 the majority of it was removed and transported to Glasgow, the remainder being left until after Lady Burrell's death in 1961.[77] Burrell had given his entire collection to the City of Glasgow in 1944, but it was not until 1983 that the Collection was finally opened to the public in its new home in Pollok Park, within easy reach for the population of Glasgow to enjoy.

The modern building that houses The Burrell Collection was specifically designed to incorporate the architectural art treasures into its fabric. Approximately one-third of the stained glass is on display in the galleries (Fig 42). The Restaurant has been hung with 16th-century heraldic glass from Vale Royal, Fawsley Hall and Compton Verney, as a banqueting hall of the period would have been. The windows are lit by natural daylight which illuminates the glass with varying intensities from hour to hour and season to season. In the brilliant, low, winter sunshine the rich ruby reds and cobalt blues are reflected on the Portland stone floor and grey painted walls. In the overcast grey days the delicate

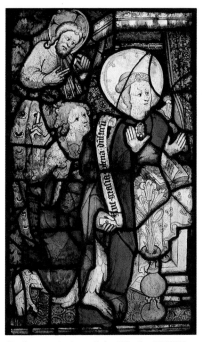

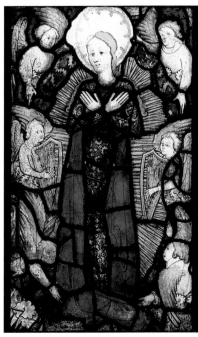

43 **Annunciation of the Virgin** *(45/588),*
English (Hampton Court), 1400–30

44 **Assumption of the Virgin** *(45/389),*
English (Hampton Court), 1400–30

paintwork on the faces and draperies of the paler windows can be closely studied to enjoy the skill of the medieval glazier. Intricate details can also be studied in the internal artificially lit Stained Glass Gallery where some of the smaller panels are on display. The original settings for the glass in Hutton Castle have been faithfully reproduced in the Drawing Room, Dining Room and Hall where some superb English heraldic panels can be seen. The remaining two-thirds of the stained glass is safely housed in custom-built stores along with the rest of the Collection, and any conservation work is carried out in-house in the stained glass conservation workshop.

The Collection is not static. In 1979 two windows were bought by the Trustees at Sotheby's. The *Annunciation* (Fig 43) and *Assumption of the Virgin* (Fig 44) originally came from the domestic chapel of Hampton Court in Herefordshire and date from between 1400 and 1430.[78] In 1924 they were sold through Drake and Thomas to an American collector. Whether Burrell was aware of them at the time is not known, as his correspondence with Drake began in 1925 and no mention is ever made of them. However, they fit in exactly with his taste: they display a high degree of skilled craftsmanship and artistry, they are English, early 15th century, and the figures of the angels and the Virgin are at once both playful and delightfully painted. Burrell would have loved them.

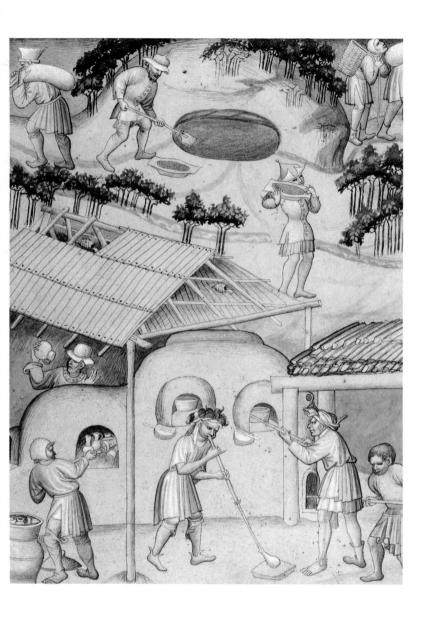

45 Gathering Beech-ash, and Glass-blowing
15th-century English manuscript
(Reproduced by permission of the British Library (ADD MS 24189)

HISTORY OF THE TECHNIQUES
AND MATERIALS

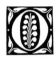RIGINAL recipes and treatises on the art of glass-making and painting are very rare. Craftsmen, whose skill and knowledge ensured their livelihood, were naturally cautious about disclosing trade secrets. Information relating to the technique of stained glass was seldom written down, but passed on verbally from master to apprentice. As a consequence, knowledge of some of the methods used by early glass-makers has since been lost. A few documents from the 12th to the 19th centuries have survived. They provide a fascinating insight into the materials, techniques and working conditions of the men who made stained glass.

RAW MATERIALS
Who wold wene it possible yt glasse were made of ferne roytes?
SIR THOMAS MORE, 1557[1]

Soda-glass was the first type of glass to be used for making stained glass windows.[2] Its main components were sand and the ashes of seaweed or other marine plants. Some sands and plants were more suitable than others, and as a result, most early window glass production occurred along the coastlines of the Mediterranean where the best ingredients were to be found.[3]

Glass manufacturing centres were also situated inland, close to trade routes, where the raw materials could be transported across the Alps and along the Rhine, the Seine, the Danube and their tributaries. In the 12th century, demand for glass dramatically increased and forced glass-makers to look elsewhere for more abundant supplies of ash. The great deciduous forests of northern Europe provided a plentiful source, beech-ash being the most preferred. Consequently, the centres of coloured glass production in the Middle Ages were situated close to the forests where beech trees grew in abundance[4] and where rivers ensured rapid transportation of the finished product (Fig 45). The Rhineland, Alsace-Lorraine, Normandy, Lower Burgundy and Bohemia all became important glass manufacturing areas, supplying glass for the new cathedrals that were being built throughout Europe.

The sand and ash were transformed into glass by heating them together in a large pot, or crucible, which was placed in the middle of a

furnace. The ratios of the different ingredients were vitally important: if too much sand was added the melting temperature became too high and could not be attained, and if too much ash was used, the glass did not harden sufficiently and was soluble in water. Often a third ingredient was added, lime, which had the desired effect of stabilizing the glass and making it harder and more durable. However, if too much or too little lime was added by mistake, then the glass quickly deteriorated.[5]

The change in ingredients, from seaweed to beech-ash, had an unexpectedly drastic effect on the quality of the glass. Soda-glass, rich in sodium oxide, had been extremely stable. However, the potassium oxide present in the beech-glass made the material almost twice as likely to corrode.[6] The beech-ash also contained varying amounts of lime, depending on where the trees had grown and where they had been burnt and as a result the amount of lime in each batch was very difficult to control. Frequently, the quality of the glass was very poor.

The necessity for being scrupulously careful when handling the ash is described by Theophilus in his definitive 12th-century treatise *On Divers Arts:*

> If you have the intention of making glass, first cut many beechwood logs and dry them out. Then burn them all together in a clean place and carefully collect the ashes, taking care that you do not mix any earth or stones with them.[7]

By the 17th century soda-glass was again highly favoured, and glass from this period onwards is noticeably more durable than that of the previous five centuries.[8] In 1699, Monsieur Haudicquer de Blancourt published *The Art of Glass*, a 355-page study of the techniques and materials used in glass-making: 'A work containing many Secrets and Curiosities never before Discovered' (frontispiece).

> *Soda*, which comes from Egypt and Spain, derives its name from the abundance of Salt it contains; it is made from the same herb as the *Polverine* and *Rochetta* of the *Levant* . . . and though this herb grows in great quantities in many places, and comes naturally among water, and commonly flourishes near lakes, yet it is planted on the banks of the Mediterranean in *France*, and *Spain*, and *Egypt*, where by reason of the heat of the Climate, it grows in great quantities; but it has the most Sharpness and is strongest in *Egypt*, where there is never any rain . . . This herb, called by most *Kali*; has yet diverse other names . . . *Soda, Alkali, Salicornia, Anthilloides, Kelp, Antillis, Kali, Salsola, Alga of Venice* . . . There are several sorts of it, but most of them are good for nothing, flying all away in smoke, as does the knotty and thorny sorts of it, or *Kali Spinosum*, which is found in

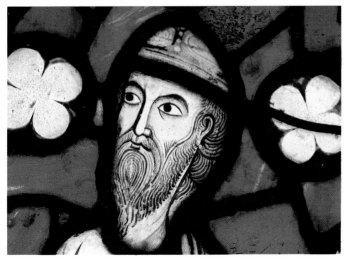

46 **Streaky ruby glass** *Detail of Prophet Jeremiah, Fig 17*

several places about the River *Thames*, and in other Maritime places in *England*, which is the reason the *English* never make use of it for Glass . . . The *Kali* of the *Levant* is best of all.[9]

According to Blancourt, another essential ingredient called Tartar came from the dregs of red wine that were left in the bottom of many a wine bottle. It made the glass whiter.[10]

The beech-ash, which was used primarily to help melt the sand, had an additional advantage in that it contained considerable amounts of iron and manganese. Depending on the heat of the furnace, the supply of oxygen and the total amount of time that the pot remained molten, these two impurities could produce a wide range of colours: white, pale blue, green, yellow, amber, brown, flesh, pink, purple and violet.[11] Theophilus described the process:

> . . . if you see any pot happening to turn a tawney colour, like flesh . . . take out as much as you wish, heat the remainder for two hours, namely, from the first to the third hour you will get a light purple. Heat it again from the third to the sixth hour and it will be a reddish purple and exquisite.[12]

Another method by which glass was coloured was by the deliberate introduction of specific metal oxides to the pot. Copper, cobalt, or iron oxides produced glass that was, respectively, blue-green, blue-violet, or yellow-amber. Under certain conditions it was also possible to make the copper oxide produce a deep red colour, known as ruby.[13] This last colour was so dense that to make it transparent it was necessary to streak

the colour throughout the glass. Although it is not known how this was done, it is thought that the glass-makers may have deliberately not mixed the colour thoroughly in the pot. 'Streaky ruby' such as this can be seen in some background pieces of *Jeremiah* (Fig 46). The practice of adding gold, to make a beautiful pink-ruby colour, is believed to have been first used in the 16th century.[14] The addition of each oxide was a precise art, and once again, the glass-makers needed to take special care to avoid impurities:

> The Vessels or Pots which serve for one Colour must not be made use of for another, and every Colour ought to have its own Pot . . . It is necessary also to be observ'd, that all the Dose of the Colouring ought not to be thrown on the melted Glass at once, but at several times, and in proportion according to the quantity of it, stirring each time the Materials that they may both mix and incorporate, and at the same time to prevent them from rising and running over.[15]

A particular problem arose in the production of glass in the mid to late 14th century when the Black Death killed many of the glass workers. With their disappearance some of their secret recipes were lost. It took many years for the glass industry to recover and glass from this period is particularly unstable.

Glass is damaged by water and high humidity. The corrosion which results is found in all periods of stained glass and takes many forms, from tiny black specks on the surface, to huge areas of corrosion which join up and eventually produce holes (Fig 47). It can produce an iridescent bloom, or an insoluble white coating on either surface. All of these have the effect of darkening the glass and making it less transparent.

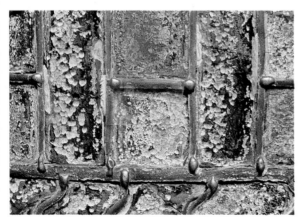

47 **Corrosion detail**
(Photograph taken by author)

Sheets of glass have been made since the 1st century AD by collecting a bubble of molten glass on the end of a long blowpipe and enlarging it until it hung down like a long bladder (Fig 48). After the bladder had been blown into a long thin bubble, both ends were cut off to form a cylinder known as a muff. A cut was made along its length with a pair of shears or a hot iron. When the cut muff was heated in a furnace, it became soft and could be opened out to form a large square (Fig 49). An alternative method, which was developed later, in the 4th century,[16] was to cut off one end of the bubble of glass, attach the bubble to a pole, which was then spun rapidly (Fig 50). The centrifugal forces which acted on the spinning bubble caused it to fan out, forming a large circular sheet of glass known as a crown which was thicker in the middle than at the circumference (Fig 51). Before they were ready for use the sheets of muff and crown glass had to be slowly cooled in an annealing oven to prevent them from spontaneously shattering (Fig 52).

The working conditions of the men who made the glass sheets were described by Blancourt:

> The Gentlemen of the great Glass-Houses Work only Twelve Hours, but that without resting, as in the little ones, and always standing and naked. This work passes thro' three hands, the first thro' the hands of Gentlemen Apprentices, who gather the matter with their hollow Iron . . . Then a second Work-Man more advanc'd in the Art, takes the Iron and gives it three heats more, and setting it on the Marble, makes it into a Lump. Then the Master Work-Man takes it and makes it perfect by blowing it, and making it ready to be Worked: then there comes a Servant with a sharp Tool of Wood, which he thrusts into the end of the Lump or Mass, and the Master Work-Man with an almost inconceivable Address and Art works it at the heat of the Mouth of the great Working-Hole . . . And it is of these Plates they make Window-Glass for the Glasiers.
>
> . . . they always work . . . in the Summer almost naked, and very few Cloaths on in Winter, only taking care to cover their Heads for fear of catching cold. It must be own'd, those great and continual Heats which these Gentlemen are exposed to, from their Furnaces, are prejudicial to their health, for coming in at their Mouths, it attacks their Lungs, and dries them up; whence most part of them are pale and short-lived, by reason of Diseases of the Head and Breast.[17]

It is unlikely that conditions would have been much different in Theophilus's time.

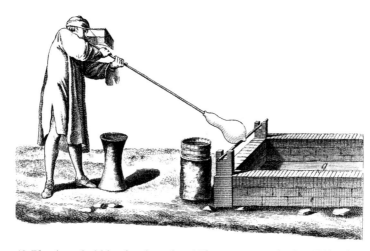

48 Blowing a bubble of molten glass *18th-century engraving from Diderot's* Pictorial Encyclopedia of Trades and Industry *(pl 241)*

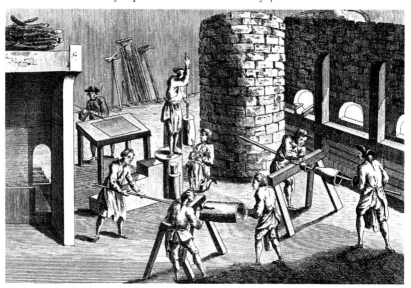

49 Cutting and flattening a sheet of muff glass *18th-century engraving from Diderot's* Pictorial Encyclopedia of Trades and Industry *(pl 250)*

54

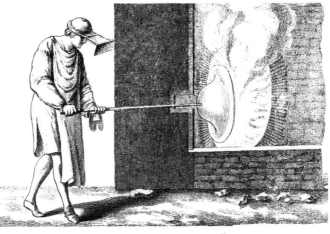

50 **Spinning a bubble of glass to form a crown**
18th-century engraving from Diderot's Pictorial Encyclopedia of Trades and Industry *(pl 245)*

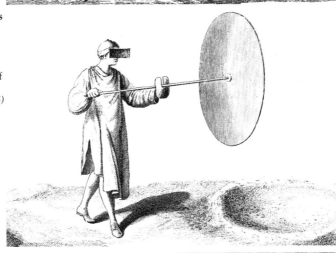

51 **Crown glass**
18th-century engraving from Diderot's Pictorial Encyclopedia of Trades and Industry *(pl 245)*

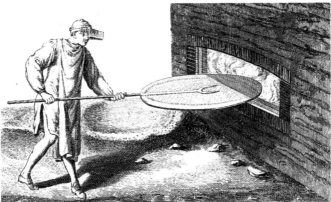

52 **Placing finished crown in annealing furnace**
18th-century engraving from Diderot's Pictorial Encyclopedia of Trades and Industry *(pl 246)*

Glass made and coloured in this way it still known today as pot-metal glass. The range of colours used in windows prior to the 14th century was restricted by the colours of glass that were available. Despite the limitations, the illusion of depth and three-dimensional space that the glass-makers managed to create is extraordinary: the cooler blues and greens appearing to recede into the background, allowing the brighter rubies, yellows and whites to come forward. A brilliant example of the intensities of pot-metal colours can be seen in the decorative 13th-century English roundel in blue, yellow and ruby (Fig 53).

By the beginning of the 14th century ruby glass was rarely streaked. Another method, of dipping the blowpipe into a pot of molten ruby glass, blowing a bubble, and dipping the bubble into a second pot of clear glass, produced a sheet of transparent glass which consisted of two superimposed layers, the upper a thin ruby, the lower a thicker clear. This enabled the ruby to be thin enough to achieve transparency while yet retaining the strength of the sheet. This layering technique, which is also used today, is known as flashing. It is surprising that flashed glass was not generally used for windows before the 14th century as the technique was known to vessel glass-makers in Roman times. The

54 **Detail of wheel-ground holes in flashed ruby glass**
(Photograph taken by author)

Portland Vase in the British Museum is a superb example of hand-blown layered glass. There appears to have been very little contact over the centuries between the craftsmen who made vessel glass and those who worked with stained glass. Many of the vessel glass techniques were known about and widely used long before they were adopted by medieval glaziers.

The glaziers soon realized that the upper layer of flashed ruby glass could be abraded with emery or some similar hard medium. This allowed the clear glass to be seen through the ruby, and enabled the glazier to work with two different colours on one piece of glass. It took a great deal of patience to abrade large areas of glass, and the use of this technique was always restricted by time and cost. Surprisingly, it was not until much later, during the 15th century, that other colours such as blue and green were flashed and abraded in this manner.[18] The surface of the glass immediately surrounding the abraded area often looks rough and scratched, although with the use of copper wheels in the 16th century some very neat abrading was achieved (Fig 54). The same tools were used in the 18th century by William Peckitt of York:

> Then the glass cutter, by his apparatus of wheels and other instruments (as commonly used) with water, or oil, and emery, must grind off so much of the coloured glass from the uncoloured glass, which must appear in ornamental devices in parts, polishing the same with oil, tripoli, and putty, as his ingenuity shall dictate.[19]

Since the 19th century hydrofluoric acid has been used, leaving a clean, hard outline in a fraction of the time taken to abrade the glass by hand. Needless to say, acid-etching instantly replaced abrasion as a suitable method for removing the flash. Evidence of its use can date an otherwise authentic-looking window. Of the two little birds illustrated (Fig 55, detail), the one on the right is a 19th-century copy of the 16th-century one on the left.

55 **Detail showing difference between 16th-century abraded bird** *(left)* **and 19th-century copy** *(right)*

The thickness of the glass sheet changed considerably over the centuries. In the 11th, 12th and 13th centuries the glass was very thick and uneven on the surface. Gradually it became smoother and thinner until in the 18th and early 19th centuries it was often no thicker than 1 mm. The mid-19th-century revival in stained glass was accompanied by a desire to reproduce the colours and quality of glass of the Middle Ages. Chemical analysis of 12th- and 13th-century fragments was instigated in 1849 by Charles Winston, who employed 'Mr Medlock, of the Royal College of Chemistry, and the practical skill of Mr Edward Green, of Messrs. Powell's glass-works in Whitefriars' to do the work.[20] After much frustration and many trials, a beautiful, hand-blown, coloured glass was produced, known as English Antique, which is still made today.

THE CARTOON

In early times sheets of glass were cut over a cartoon which had been drawn with lead or tin on a whitewashed table[21] or plaster floor.[22] Parchment and paper were used once they became more readily available in the 14th century.[23] The accuracy of the drawing in the cartoon was essential to the final appearance and colour of the window, and consequently it was often the task of the most experienced and highly paid man in the workshop to design and draw up the cartoon. Sometimes individual artists from outside the workshop were asked to do this work, as is described in *Il Libro dell' Arte*, a handbook for craftsmen written by Cennino d'Andrea Cennini in 1421:

> . . . ordinarily those masters who do the work [stained glass] possess more skill than draftsmanship, and they are forced to turn, for help on the drawing, to someone who possesses finished craftsmanship, that is, to one of all-round good ability. And therefore, when they turn to you you will adopt this method. He will come to you with the measurements of the window, the width and the length: you will take as many sheets of paper glued together as you need for your window; and you will draw your figure first with charcoal, then fix it with ink, with your figure completely shaded, exactly as you draw on panel. Then your master takes this drawing, and spreads it out on a large flat bench or table; and proceeds to cut his glasses, a section at a time.[24]

It was imperative that all of the designer's ideas were precisely passed on to the craftsmen who later cut and painted the glass. This meant that a great deal of information had to be drawn on the cartoon, as can be seen in one of five late 16th- and early 17th-century stained glass cartoons

Within the cartoon, the following text appears:

SEPJMACHVS.

SGORDIANVS.

HEINRICH V. VLM.
DES. FVRSTLICHEN
GSTIFTS. VND GOTSHVS
KEMPTEN. DECAND.
ANO DOMINI · 1 6 0 6 ·

56 17th-century Swiss cartoon
(35/654)

57 Detail of glaziers' sorting mark
(Photograph taken by author)

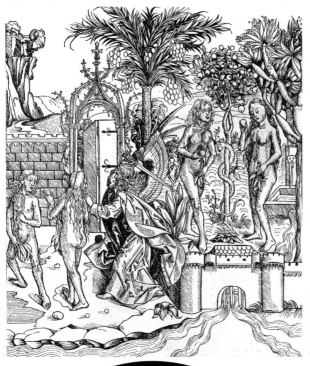

58 **Expulsion from the Garden of Eden** *(4/5), Detail from the* Nuremberg Chronicle, *1493*

59 **Expulsion from the Garden of Eden** *(45/445), Flemish, 16th century*

which were bought by the Burrell Trustees in 1982 (Fig 56). The outline of where each piece of glass should be cut is clearly indicated in red ochre. Inside each outline a letter denotes what colour of glass is required. The intricacies of the paintwork are shown in the fine drawing of the central coat of arms, of Heinrich von Ulm, Dean of Kempton in Bavaria, his patron saints who stand next to elaborate columns, the religious scene with three saints at the top of the panel, the four shields – one at each corner, and the donor's name, occupation and date of commission at the bottom.

Another way of transferring information was to give each piece of glass an individual letter or number, by painting on the front or scratching into the back surface (Fig 57). This ensured that even though a tiny piece of glass might be worked upon by different craftsmen in the workshop, its position in the window would never be forgotten.[25]

The stained glass designers drew their inspiration from many sources. Illustrated biblical texts such as the *Biblia Pauperum* (Poor Man's Bible) and the *Speculum Humanae Salvationis* (Mirror of Man's Salvation) were frequently used, as were the Apocryphal Old and New Testaments. One such source, the *Nuremberg Chronicle*, was printed in 1493 by Anton Koberger (godfather to Albrecht Dürer). A fully documented history of the world from the first day of creation until the end of the 15th century, it contained 1809 woodcut illustrations. One of these illustrations, showing the *Temptation of Adam and Eve* and the *Expulsion from the Garden of Eden* (Fig 58) was used as the cartoon for a 16th-century Flemish roundel (Fig 59). Every detail is identical: the figures of Adam, Eve, the serpent and the Archangel Michael, the date palm and apple tree and the architectural features. (Another point of interest was noticed during its conservation in 1985. Over the years it had broken into 18 pieces. Most of the break-edges were clean, but two had traces of paint along the cracked edge, although the panel showed no signs of having been overpainted at a later date. It is likely, therefore, that the glass cracked in the kiln, the paint ran into the cracks and the stained glass craftsman simply joined the broken pieces together with strips of lead. So fine and costly must have been the task of painting this roundel that it was better to keep it, though damaged, than to throw it away.)

Cartoons were valuable assets that would often be re-used or sold to other studios. There were many ways in which several windows, based on the same design, could be made to appear very different. Details were changed and inscriptions altered. The design, or elements within the design, were reversed, and the colours of the glass changed. If one compares the 15th-century Rhenish panel of *Solomon and Sheba* (Fig 60) with an almost identical panel in the Cloisters Collection in New York (Fig 61), it is clear that the same cartoon has been used. There is a noticeable similarity in the positioning of the figures, the architectural

60 **Solomon and Sheba**
(45/432),
Rhineland, 15th century

61 **Solomon and Sheba**
(47.170.103)
(Reproduced by permission
of the Metropolitan
Museum of Art, New York)

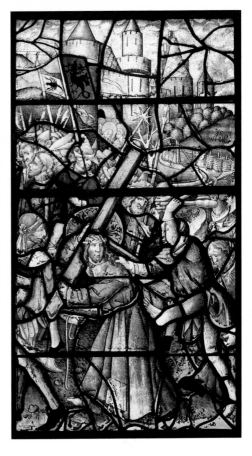

62 **Christ Carrying the Cross**
(45/431), Rhineland, 15th century

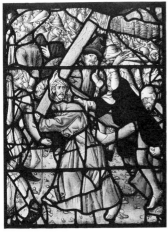

63 **Christ Carrying the Cross**
(Great Bookham Church, Surrey),
Rhineland, 15th century
(Reproduced by permission of
the Royal Commission for
Historic Monuments, England)

background and the colours used. However, the painting styles are quite different: the brickwork and the thrones have been tonally reversed, and the faces in the Burrell panel are more lightly painted. A 15th-century Rhenish panel depicting *Christ Carrying the Cross* (Fig 62) used the same cartoon as a window that is now in Great Bookham Church, Surrey (Fig 63). The expressions on some of the faces compare well, especially the bald-headed figure on the extreme right. Two other windows that have also used this cartoon are in Cologne Cathedral, Germany and Cleveland Cathedral, USA.[26]

CUTTING THE GLASS

Having drawn the cartoon, the next step was to cut the glass. In the 12th century this was done using two tools: a hot iron to run a fissured crack along the surface and a notched iron bar called a grozer to nibble

away at the broken edges. Skilfully used, these two tools could create the most wonderfully intricate shapes:

> ... heat on the fireplace an iron cutting tool, which should be thin everywhere except at the end, where it should be thicker. When the thicker part is red-hot, apply it to the glass that you want to cut, and soon there will appear the beginning of a crack. If the glass is hard (and does not wet at once), wet it with saliva on your finger in the place where you had applied the tool. It will immediately split, and, soon as it has, draw the tool along the line you want to cut and the split will follow ... take a grozing iron ... and trim and fit all the pieces with it.[27]

In the 16th century, the hot iron was replaced by a diamond-tipped glass cutter,[28] although the grozer was kept as a useful tool. It is no coincidence that the diamond was first used in the 16th century – it was more a matter of necessity. Sheets of glass were being produced that were very much thinner than had previously been possible, and with their thinness came an increased tendency for them to shatter under stress. The amount of pressure required to cut glass with a diamond is considerably less than that with an iron and grozer, and consequently must have saved the 16th-century glazier a great deal of time, money and glass.

Towards the end of the 19th century another type of cutter was invented – the tungsten-carbide wheel. Once again, its introduction coincided with many new types of glass, such as English Antique (see above). Mr E. W. Twining, in 1928, wrote in his book *The Art and Craft of Stained Glass:*

> One frequently finds on the glazier's bench ... a diamond and a grozing iron. Of these two, the latter can be quite dispensed with, although it at one time was solely used for glazing ... The diamond is undoubtedly the better instrument for making long, straight cuts, but for curves and all other odd shapes into which antique glass is required to be cut for stained glass windows proper, the wheel is by far the better tool, for the wheel can do everything which is possible with the diamond; and many things which, at any rate in inexperienced hands, the diamond could not be made to do.[29]

PAINTING

Once cut, each piece of glass could be painted using a variety of metal oxides. Iron oxide was most commonly used, but others that were sometimes used include cobalt, copper, lead, manganese, titanium and

zinc. Pigments, such as burnt umber and Indian red, were often added to give a slight hue to the painted surface, but when held up against the light the paint always appears black. Another essential ingredient was a powdered low-melting glass (known as a soft glass), which enabled the paint to fuse on to the surface of the glass at an optimum temperature which would not melt the piece of glass itself. To transform the dry ingredients into a paste which could be used for painting, water and gum arabic were added. Other binders that were sometimes used included honey, vinegar, wine, treacle and urine.[30] The preparation of paint is described in *A Booke of Sundry Draughtes*, by Walter Gedde, dated 1615:

To make a faire Blacke

Take the Scales of Iron & Copper, of each a like waight, & put it in a cleane vessell that will indure the fire, till they be red hotte, then take half as much Ieate, and stamp them into smal pouder, then mix them with Gumwater, & grind them fine upon a painters stone and so drawe with it upon your glasse.[31]

The principles of glass painting were (and are) quite different to those of other disciplines, such as oil or water-colour. With every application of paint, an obscuring layer is added to the surface of the glass, thus rendering the glass more and more opaque. Light had to be allowed to filter through the glass to reveal its inherent colour. If too much paint was used, the glass, when held up to the light, simply appeared black. Glass painting, therefore, was a balancing act, between light and shade, opacity and transparency, and one which required great skill. A good glass painter and designer was paid more than the other craftsmen who worked beside him, as the following account from 12 March 1351 for the glazing of St Stephen's Chapel, Westminster, clearly shows:

To Master John Lyncoln and Master John Athelard, glaziers, working on the designing and arrangement of the glass for the windows of the King's chapel at Wyndesore, on Monday, Tuesday and Wednesday, each receiving 12d a day, 6s. To William Waltham, John Waltham, John Carlton, John Loord, and Nicholas Dadington, 5 glaziers painting glass for windows of the Chapter house, for six days at 7d a day, 17s 6d. To John Couentre, William Hamme, John Cosyn, Andrew Horkesle, William Depying, William Papelwyk, John Brampton, William Bromle, John Lyons and William de Naffreton, 10 glaziers, working on the breaking and laying of glass for the glazing of the said windows for the same time, at 6d a day, 30s. To Robert Saxon, labourer, assisting them, at 3d a day, 18d.[32]

It was not uncommon for the painting to be contracted out to the same

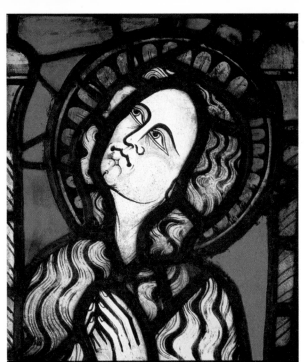

64 St Mary of Egypt
(45/366),
French, 13th century

**65 Detail from
Conversion of the Jew
(Fig 28)**
*(45/92), Norwich School,
15th century*

**66 Detail from
Solomon and Sheba
(Fig 60)** *(45/432),
Rhineland, 15th century*

professional artists who had drawn up the cartoon. The task of painting draperies, backgrounds and other simple areas was often given to less experienced painters, who were accordingly paid less for their labours.

Because there is such a vast range of glass in the Collection, it is possible to study a wide variety of different painting techniques and styles that developed in stained glass over 700 years, some of which are described in detail below. Every period, country, region and workshop developed a uniquely individual style. Sometimes it is even possible to attribute a window to an individual artist.[33]

A particularly lovely example of early 14th-century French glass

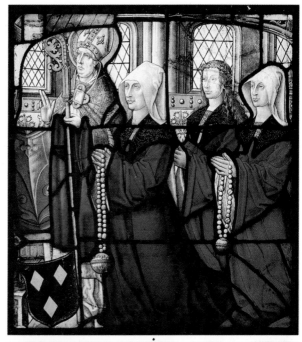

**67 Female Donors
and their Patron Saint**
(45/436),
Rhineland,
early 16th century

**68 Details
of Donor's Head
(Fig 67)**

painting is *St Mary of Egypt*[34] (Fig 64). On her face shadow and tone have been achieved by varying the thickness of the tracing-line on her chin and under her eyes. Elsewhere a very light wash of paint has been used to highlight the contours of her cheeks.

One of the characteristics of the Norwich School of glass painters in the 15th century was their superb use of line-work, as can be seen in a detail from the *Conversion of the Jew* panel (Figs 65 and 28). Deft brush-strokes neatly outline the faces, giving them character and reality and style to the hair in beautiful tight curls. By lightly lifting off some paint with a soft

69 **Detail from Lady of Shalott**
(Fig 39)

brush or pointed stick, highlights have been added to the tips of the noses, cheeks, foreheads and lips.

The head of *Solomon* (Figs 66 and 60), also from the 15th century, shows another method of applying paint that was commonly used throughout the 15th and 16th centuries, but which had been first used towards the end of the 14th.[35] Stipple shading was done by first applying a light wash of paint over the entire surface of the glass, and then lifting off certain areas by lightly dabbing the surface with a large, thick brush made of badger hair. Invariably paint covered most of the surface and dulled the transparency of the glass. Highlights were made by scratching tiny lines into the shading, which lightened the hair, defined the features and produced a well-modelled head.

Another panel which, like *Solomon and Sheba*, comes from the Rhineland, shows how painting styles changed within a few decades. The figures of *Female Donors and their Patron Saint* (Figs 67 and 68) date from the beginning of the 16th century. Here the painting is much softer and smoother. The line-work is exquisitely delicate, especially around the eyes and on the collars. The faces themselves are well rounded, fleshy and very lifelike; there has been no attempt to hide the patron saint's double chin, or the bags under the donor's eyes.

Matthew Maris's *Lady of Shalott* (Figs 69 and 39) shows an interesting use of glass paint by the 19th-century Dutch oil painter. The colours used are earthy and subdued. The pale figure of the Lady of Shalott stands out against the dark background, both of which have been painted with washes of different coloured paints. There are none of the intricate details of medieval glass painting, but there is a subtlety and a dream-like quality about it which was much admired by Burrell.

In the 17th century it was not uncommon for a single piece of glass to take up to six days to be painted:

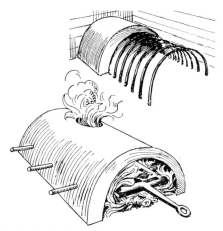

70 **Early clay-built kiln**
(Drawing reproduced from
English Medieval Painted Glass
by Le Couteur, p14)

71 **17th-century brick kiln**
(Engraving reproduced
from The Art of Glass,
by Blancourt, p270)

... you must paint in this manner: Trace your piece with Black, and let it dry for two days entirely, do it over very lightly and equally with a Wash so thin laid on, as not to efface the first Lines, and let it dry for two Days; after this run it over again with the same Wash where you find it convenient to give a second Tinge, and let it dry two days longer: Then give to it the Lights; and convenient Heightenings, take the sharp But-end of your Pencil, or pointed Stick, or Pen, as before, and take off the colour of the first Wash, in the most necessary places, and so your Work will be finished.[36]

FIRING THE PAINT

To secure the paint permanently on the glass, it had to be fired in a kiln at around 600° Celsius. At this temperature the soft glass melted and fused with the surface of the coloured glass. It was critical that the correct firing temperature was achieved. If it was too low the paint was not properly secured, and came off with time. If it was too high the paint burned, causing blisters on the surface. The blisters retained moisture and rainwater, which encouraged deterioration of the glass, and, in turn, led to further loss of paint. Estimating the firing temperature was very much a matter of experience, but as a rough guide, when the glass glowed red-hot in the kiln, the critical temperature had been reached.

The earliest type of kiln measured about 45 cm (18 in) high and 60 cm (24 in) long, and was made from bent canes covered with clay and horse dung (Fig 70).[37] By the early 15th century they were made from 'iron

cases'[38] and in 1615 'free-stone or brick'[39] was used. The size also increased, being 'fower foote square, and three foot high'[40] (Fig 71). The brick kiln was still in use when Charles Winston wrote his *Hints on Glass Painting* in 1847,[41] and was just beginning to be superseded by other, gas-fired kilns in 1905.[42] It is interesting to note that William Peckitt, in the late 18th century, was using 'soft clay and horse Dung'[43] to close up the mouth of the annealing oven. Modern kilns, which heat up and cool down within a few hours using microwave technology, are a far cry from the brick kilns, which could take two and a half days to finish a firing:

> After your glass is fully painted, and the Draughts perfectly finished, the difficulty will be to Bake the Glass ... Take good Quick-lime well digested, fearced, and finely pulverized ... then make a very even lay thereof, about half an Inch thick, and then lay the pieces of broken Glass, and afterwards another lay of Powder ... the reason for this Stratification of powder and old Glass, is to prevent any injury from the violence of the Fire ... This done upon the third bed of powder, lay a lay of painted Glass, and so continue each lay of powder and Glass ... until all the pieces of paint are in. Your Furnace being thus ordered, and the lute dry'd very well, begin to heat it gently with some Charcoal on the outside of the Furnace ... and so very leisurely improving it, lest the Glass should be broken, or the paint spoil'd. Continue thus for two Hours, then thrust the Fire in further, and let it remain there for an Hour, putting it in little by little under the stove, where leave it for two Hours longer, then increase the Fire by degrees for two Hours ... keep it thus very violent for three to four hours; you must be very cautious and circumspect during the whole Work.
>
> As soon as you find your Colours almost done, improve the Fire ... and make the Flame environ and reverberate over and round about the Stove, which must be continued until you have finished, this will be in about twelve or fourteen hours; then let the Fire go out and the Work cool of its self, and so take it out, and 'twill be finished.[44]

YELLOW-STAIN

Perhaps the most significant development in the history of the techniques of stained glass was the realization, around the year 1300, that compounds of silver (chlorides, nitrates, oxides and sulphides) could stain glass yellow. The mixture, as described below, was painted on the reverse side of the glass. When heated, it soaked into the glass and turned it various shades of yellow. Because a chemical reaction with the glass took place, it was understandable that some glass, with a specific

chemical structure, should stain better than others. Potash glass, high in potassium oxide, which was used throughout the Middle Ages, was unreliable in taking a good, even stain: the colour could vary within a few inches from a pale lemon colour to a deep orange.

> Take a quantity of fine silver, and cut it into small peeces and put therto a little Antimonium beaten to pouder, and put them to-gether in a melting-pot, and set them on the fire well covered round about with hotte embers the space of a hower, then take it from the fire, and poure it into the bottom of a cleane earthen vessell that will abide the heate thereof: after it is cold beat it into a fine poulder, and grind it on a Painters stone, and when it is well ground, take six times as much Ocker as the Silver weighs, and seven times as much old earth that hath bin scraped off from enamaled worke: after that, let it be well ground, then put all this together in a pot with gume-water, and stirre it well aboute and so use it.[45]

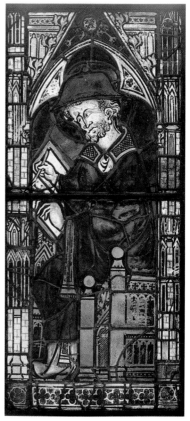

72 **St Jerome** *(45/369)*, *French, 1324–40*

It would appear that yellow-stain was at first used rather cautiously and experimentally. One of the earliest examples of yellow-stain in the Collection (*c.*1325) is a large seated figure of *St Jerome* (Fig 72). Not all of the yellow colour in the window is stain: his chair, writing desk, collar, scarf and the circle above his head are all pot-metal yellow. However, the architectural framework, St Jerome's hair and beard, his book and quill and the lowest part of his tunic have all been executed with a stain which varies in intensity from a pale lemon to a deep orange. This mixed use of yellow-stain and pot-metal yellow indicates a slight reluctance to use stain for large areas of flat colour, probably due to its unpredictable nature.

Glass painters, liking a challenge, were not daunted, and by the middle of the century it was widely used. Small yellow-stain roundels became fashionable, being cheaper to produce than coloured glass panels. Often

71

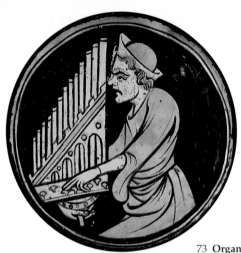

73 **Organ Player** *(45/27), English, 14th century*

they would be set into quarry windows, whose diamond-shaped pieces of glass would also be painted with stain (Figs 25 and 26). The *Organ Player* (Fig 73) is a rare example of a mid-14th century, English secular roundel. The organist appears to be having difficulty in holding the organ, pumping the bellows, and playing the keyboard all at the same time. The folds of his tunic have been skilfully drawn, but it is the poor man's expression which gives the roundel its charm: his face is set with a permanent scowl and the corrosion on the glass does nothing for his complexion. Needless to say, Burrell 'liked this panel very much'.[46]

One of the best examples of yellow-stain in the collection is the small, rectangular panel of *Princess Cecily* (Fig 74), whose long golden hair, yoked collar and crown have all been stained. Originally she was placed in the bottom of the Royal Window in the north-west transept of Canterbury Cathedral, beside the donor-portraits of her parents (Edward IV and Elizabeth Woodville), her two brothers and four sisters, who were alive when the window was being made (*c*.1483).[47]

On 13 December 1643, following the Ordinances issued in parliament on 28 August the same year for the 'utter demolishing, removing, and taking away of all monuments of superstition and idolatry'.[48] The window was razed to the ground. That Cecily has survived at all is remarkable, not least because of Burrell's request that 'part of [the] blue background of Cecilia panel be used for [the] Crucifixion panel'.[49]

The style of the painting in the Royal Window was very heavily influenced by Flemish artists of the period,[50] especially in their use of stain. In the 16th and 17th centuries Flanders and the Low Countries excelled in the art of painting yellow-stain roundels. The use of the term roundel may also be used for small yellow-stain panels which are rectangular, square, or oval. One such panel is of a *Shepherdess* (Fig 75)

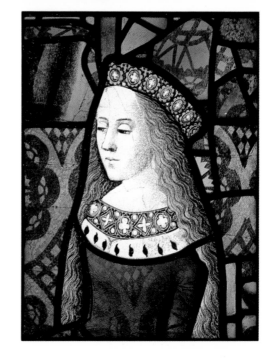

74 **Princess Cecily**
(45/75),
Canterbury Cathedral,
c.1483

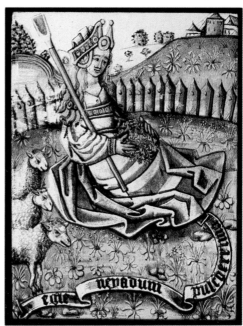

75 **Shepherdess** *(45/456),*
Flemish, early 16th century

76 Detail from the Life of St Francis (Fig 36)

sitting in a field of wild flowers, some of which she has gathered on her lap. To her left three sheep nudge their way into the picture. Below is a scroll inscribed *egle neyadum pulcherrima*. (It is thought that Egle was the beautiful shepherdess's name.)

Soda-glass, which was used from the 16th century onwards, took stain beautifully, in strong, even colours.[51] In the late 17th to 19th centuries, when coloured glass production was at a low ebb, and the art of making ruby glass had been temporarily lost, yellow-stain was even used to simulate red glass.

ENAMEL

The use of pigments made from coloured glass was known to vessel glass craftsmen as early as 1500 BC.[52] Unbelievably, they were not used to decorate window glass until the beginning of the 16th century.[53]

The introduction of enamels to the glass painters' repertoire allowed them to paint many different colours on one piece of glass. The whole range of colours used for enamelling did not develop simultaneously, but was introduced over a period of about 50 years, blue being the first to be used, then violet, brown, red-flesh and finally green.

Unquestionably, the masters of this art were the Swiss. In the 16th and 17th centuries they produced exquisitely painted roundels in enamel and

yellow-stain. The brightness and strength of colour is matched only by the minuteness of the drawing. In a detail from the *Life of St Francis* (Figs 76 and 36) blue enamel and yellow-stain have been used together to colour mountains, hills, trees, a river, a yellow door and the fiery flames of hell. A brown glass paint has been used for the buildings and red enamel highlights the devils and the rooftops; all in an area less than 8 cm (3 in) square.

The preparation of blue, red, purple and green enamel is described by Blancourt and Gedde,[54] but the complexities of using them are best described by Peckitt:

For a scarlet Red Colour

Take red chalk (that has a fresh soapy or oily feel, and of a rich colour) one part: of Flux, two parts: and of gum arabic, a third of a part. In a room that is free from dust flying about, lavigate the whole, or rather the flux by itself first, very fine; then the chalk and the gum together; on the Glass Plate washed very clean, with the glass muller, and pure soft water only: together then lavigate them to the temper of soft cream, putting it so made in a phiol or cup which cork or cover to keep it clean (for the least dust injures it) let it stand undisturbed a day, two, or three more to settle; then pour off the thin part on the top, upon a smooth glass plate to dry a little stiffer, and so into another clean phiol that will just hold it to be reserved for use: but it must be shook once a week to keep it mixed or the flux from subsiding. This alone will bear washing over many times, as is required on one or both sides of the glass: but when dry, wash it over with three coats of hard vitrum saturni lavigated very fine with a fourth part of gum arabic; which will in the annealing give it a glaze and prevent the frost or wet from fading it.[55]

Peckitt's description of the enamels fading is not strictly accurate. Unlike organic pigments (such as those used for oil and water-colour painting, tapestries, fabric and polychromy on sculpture), silica-based pigments do not fade in sunlight. The apparent lightening of colour is caused, instead, by the deterioration of the fusion between the powdered enamel and the glass surface. Eventually the enamel simply flakes off, leaving behind bare, white patches of glass. To prevent undue loss of pigment, both the base glass and the enamel should have similar rates of expansion and contraction. This principle is now well understood, but in the 16th and 17th centuries, the potential long-term adhesion of enamels was very much on a trial-and-error basis. Enamels from this period are much more likely to show signs of loss of pigment and deterioration on the interface where the enamel and the glass meet. It would appear from visual and documentary evidence that glass from this period which has been fired with blue enamel is particularly unstable[56] (Fig 77).

77 Detail showing deterioration at the interface between the blue enamel and the glass

Rotmt Roomtn Vr̃ ſ̃ia r̃ ſchat · Carthaga van ba
litn: Ick ſprctch Iſ̃ van loot · tñ ſandt ſt ſ
ſclitn: Het dtcktn iſ̃ Mijn ampt · Mijn praf
k ſulckſ vtrklatrt
Bracht Htſt my thit
Gthatt ♦

78 **Tile Maker**
(45/554),
Dutch, 17th century

79 **Oval medallion with shield of Dudley** *(45/195), Compton Verney, Warwickshire, late 16th century*

The increasing use of enamels was accelerated after 1 February 1636 when Louis XIII of France ordered the destruction of Lorraine. The glass-making factories which had survived there for centuries were decimated and the stained glass world was struck a severe blow. Sheets of coloured glass were no longer readily available and glass painters were forced to turn, instead, to enamels. Although many fine enamel windows were produced, none compares favourably with those made in Switzerland for colour and quality.

An interesting Dutch roundel, dated 1662, shows a *Tile Maker* at work in his studio (Fig 78). As a contemporary record of life in the 17th century, it reveals much about the tradesman: his style of dress, with his splendid hat, collar and purple stockings; the tools he uses which are scattered about his studio; his stock of tiles which are neatly piled up like books on a bookshelf; his rolls of lead beside the windows and, in the windows themselves, contemporary heraldic stained glass. Above the left window is a huge fly, and precariously close to the right window is the tile cutter's hammer.

Four late 16th-century armorials, similar to those which were hung in the tile cutter's shop, are displayed in the Restaurant in the Burrell Collection (Fig 79). They come from the private chapel at Compton Verney in Warwickshire, 9 miles east of Stratford-upon-Avon. The chapel was rebuilt in 1772 by 'Capability' Brown, who is also believed to have been responsible for the layout of the estate, both of which, along with the stately home, are presently being restored to their former glory.

One particular type of transparent pigment, known as sanguine, or in its diluted form carnation, has been the subject of much debate and confusion. Both forms of the same pigment have, over the years, been nicknamed 'Jean Cousin' after a 16th-century French painter.[57] Carnation was first used towards the end of the 15th century, but unlike yellow-stain, and enamelling, its use was never universally popular. Both processes are recognizable on the 16th-century Flemish *Allegorical Scene* (Fig 80). Man is led by his naked conscience past a group of five female vices: Avaritia (avarice), an old woman on the left, holds a knife in her right hand; Opinio (vanity), a beautiful young woman, brushes back her golden hair; Invidia (lust), another old woman, looks towards Opinio and eats her heart out; Tristitia (sadness), is a melancholy young woman; and Superbia (pride), a superb creature, is splendidly arrayed in peacock feathers and ribbons.

Sanguine is a bright orange-red colour, which was applied to the front surface to highlight lips, cheeks and patterns on the costumes, and applied to the back surface of Tristitia's skirt, giving it a much darker, redder colour than the clothes worn by the other women. Carnation was applied to the back surface, to give colour to the flesh. It has been suggested that sanguine and carnation soak into the glass like stain.[58] The presence of Litharge of Silver makes this hypothesis likely, although from experience both colours are easily removed with certain solvents. Their use was limited to a relatively short period between the 16th and 18th centuries. This may be due to the amount of time and difficulty involved in their preparation, which was considerably more than in the preparation of other pigments.

The complicated technique of making carnation was described in detail by Blancourt:

> . . . You must take Scales of Iron, and Litharge of Silver, of each a Dram, Feretto of Spain half a Dram, Rocaille three Drams and half, grind all these for half an hour on a shallow Copper-Plate, in the mean time pound three Drams of Blood-Stone in an Iron Mortar, and add it to the rest; then pound a Dram of Gum-Arabick in that Mortar to an impalpable Powder, to take off the remains of your Blood-Stone, and so add it to the rest, grinding them still continually, lest the Blood-Stone be spoiled.
>
> The best manner of grinding these is to pour Water by little and little on the Ingredients as you grind them, neither wetting them too much, nor too little, but just as much as will keep a good Temper as for Painting: Afterwards put all into a foot Glass and so drop on it through a small hollow Cane of Wood, or with your Finger, as much

80
**Allegorical
Scene**
*(45/464),
Flemish,
16th century*

Water as will bring it to the consistence of an Eggs-Yolk buttered, or a little more, then cover the Glass to preserve it from Dust, and so let it stand three Days to settle. After this, decant the clearest and purest of the Colours that rise to the top, into another Glass, without disturbing the Sediment; and two Days after it has been settled anew, pour off again the purest of the Colours as before. This done, set it in the Body of a broken Matrass, or Bolt-head, over a gentle slow Fire, to dry easily and to keep it for use.

When you have occasion for it, take a little fair Water in a Glass, and with it moisten as much Colour as you think convenient, that will be excellent for Carnation; as for the faces, which are very thick, dry 'em too, and you may moisten these in like manner with Water for Drapery, Timber-colour, and such as you think convenient.[59]

A very similar process for making carnation is described in Jean Lafond's *Le Vitrail*. He uses as his source an 18th-century text – *l'Art de la Peinture sur Verre et de la Vitrerie*, by Pierre Le Vieil. In addition to the processes described above, he discusses what should be done with the sediment that had been left at the bottom of the glass:

As for the settlement left at the bottom of the glass, it makes the real 'wood-colour' . . . to represent wood,˙ hair, birds and animals, and large draperies of a reddish colour . . . It would be best, I believe, to

keep the name carnation for the decanted red, which has stupidly been called 'jeancousin' in our workshops, and the name sanguine, the 'wood-colour' of old.[60]

Other clear examples of the use of this pigment can be seen in the architecture of Fig 65 and on the faces and orange dress of Fig 40.

INSERTION

The glaziers of the late 15th and 16th centuries sometimes abraded right through the glass to create a hole. This they filled with a perfectly cut piece of glass of a different colour and separated the two pieces with a narrow strip of lead.

A remarkable display of insertion is the 16th-century *Red and White Rose of Lancaster and York* (Fig 81) which is on permanent display in the Hutton Hall. Into a five-sided red rose has been inserted a white rose, into which has been inserted another red rose, which has a tiny circle of yellow and white flowers in the centre. This masterpiece of craftsmanship has suffered only three cracks in the inserted glass in over 400 years.

The 16th-century Fawsley Hall glass in the Restaurant exhibits many examples of insertion: stags' heads, hands, crescents, diamonds, fleur-de-lys and circles, all of which display a high degree of dexterity. Perhaps the most interesting are the circles on the shield of Sir Edmund Knightley's great-uncle, Thomas Harrowdon and his wife (Fig 82). On one of the right quarterings (Vaux – chequy argent and gules on a chevron azure three cinquefoils or)[61] two little yellow and white circles remain in place (Fig 83). They were inserted, as described above, but never securely held with lead. Instead, glass paint was used to fill up any cracks between the inserted circles and the background blue glass. Needless to say, four of the original six circles have since fallen out and the gaps have been filled with lead.

JEWELS

A very similar process to the one detailed above was described by Theophilus as *The setting of Gems in Painted Glass*:

> If in these window figures you want to set on the painted glass precious stones of another colour – hiacinths or emeralds, for example, on crosses, books, or the enrichment of robes – you can do it in this way without using lead. Whenever in their proper places you made crosses on the head of [Christ in] Majesty, or a book, or an enrichment of the hem of robes, things which in a painting are made of gold or orpiment, these things in windows should be made of

81 **Red and White Rose
of Lancaster and York** *(45/97),
English, 16th century*

82 **Shield of Thomas Harrowdon**
(45/313), English, mid-16th century

83 **Detail of inserted circle**

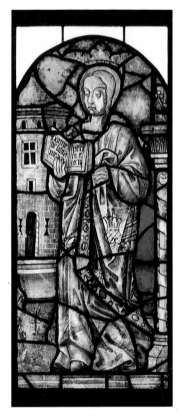

84 **St Barbara** *(45/403),
French, early 16th century*

85 **Detail of jewels
from St Barbara's cloak**

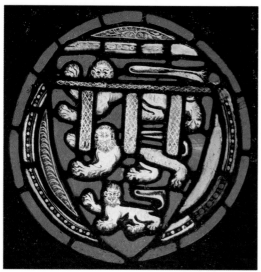

clear saffron yellow glass. When painting the goldsmith's work on
them, leave bare the places where you want to set the stones, and
take pieces of clear blue glass and shape from them as many
hiacinths as there are places to fill. Shape emeralds out of green
glass ... When they have been carefully fitted and set in position,
paint an opaque pigment around them with a brush in such a way
that none of the pigment flows between the two pieces of glass. Fire
them in a kiln so well that they will stick on so well that they never
fall off.[62]

Unfortunately they do fall off. On *St Barbara's* cloak (Fig 84), only five of
the original jewels remain (Fig 85).

LEAD

After firing, the individual pieces of glass were joined together with
strips of lead called calmes. Lead is a metal which has proved itself over
the centuries to be the most suitable material to hold pieces of glass
together in a window. It has the properties of being soft and malleable
enough to bend around the most complicated shapes, yet it is strong
enough to withstand the tremendous forces exerted upon it by the wind.
It has a low melting point and can therefore be safely soldered together
using a lead-tin alloy at a temperature which does not harm the glass. It
is also particularly resistant to the effects of weathering and does not
easily corrode. Minute quantities of other metals, such as tin, antimony,
silver or copper can sometimes enhance its strength and resistance to
corrosion.[63] The purity of the lead used in windows varies from about 94
per cent to 100 per cent.

From the 12th to the 16th centuries calmes were cast, either in pre-shaped moulds made of wood or iron, or in a wooden box lined with sand and filled with long thin twigs.[64] Calmes cast in this manner always look rough and uneven on the surface, with a width that can vary considerably, from approximately 2.5 mm ($^1/_8$ in) to 5 mm ($^1/_4$ in) along their length. The profile of the calme was rounded on the upper and lower surfaces and semicircular or concave on the inner heart. The heart was extremely thin in the centre and particularly prone to developing holes. This problem was noticed during the conservation of an early 14th-century roundel (*c.*1327) of the *Royal Arms of England* (Fig 86) prior to its display in The Age of Chivalry Exhibition which was held at the Royal Academy in London in 1987–8. Lead of a similar type can be seen in the *Marriage at Cana* window (Fig 7). Despite the holes, lead made in this manner is remarkably strong.

Sometimes the rounded upper and lower surfaces of the calme were planed into a more angular V shape by removing lead from the top and

87 **Virgin** *and*
St John the Baptist
(45/480), Rhineland,
c.1310–20

the sides.[65] Lead which has been cast and planed in this manner can be seen in two early 14th-century panels depicting *The Virgin* and *St John the Baptist* (Fig 87). These two little windows came originally from a church in the upper Rhineland and would have been placed on either side of a Last Judgment scene in which Christ judged the souls of the dead. Both the Virgin and St John are shown kneeling, with hands raised, interceding for the souls of the little half-length figures at the bottom of the windows.

Exactly when milled lead was first used has not yet been established, but it is thought to have been around the year 1500.[66] However, it is obvious from the number of windows in the Collection which still have their original lead, that by the middle of the 16th century casting was still popular.

The principle by which lead was milled was very simple: short, thick lengths of lead, known as pigs, were cast in a mould, as before. The pigs were then squeezed between two wheels which pulled the lead through a milling machine, making the lead calmes longer and thinner. Often calmes would have to be pulled through the mill several times before the required thinness was achieved. The process could not be done ad infinitum, as the lead became harder and more brittle with each successive drawing.[67]

It is common practice when making precision tools and machines to identify two otherwise identical components by scratching a notch, or some such mark, on the surface to indicate which component should go on the right and which on the left. Likewise, when constructing the milling machine, the two wheels which drew the lead were differently marked. These marks take many forms, according to the whims of the manufacturer. One unique way, which was common between the middle of the 17th century and the middle of the 19th century (although certainly used before and after these dates) was to inscribe a letter, date, or even a name on one of the wheels.

An interesting milling mark found during the conservation of *Joachim and Anna* (Fig 88) was *'Oliver 1802'* (Fig 89). He was a plumber and glazier's toolmaker who was working in London between 1799 and 1811.[68] The word plumber at this period refers to someone who worked with lead, rather than its modern interpretation. By studying contemporary glaziers' advertisements of the period, it is clear that highly skilled stained glass artists considered themselves also to be plumbers. John Rowell, a respected 18th-century glass painter considered himself a 'professor of the Ancient art of staining glass', yet advertised as a 'plumber and glass painter'.[69] The term was an ancient one, as the account for the glazing of St Stephen's Chapel at Westminster in 1351 clearly shows:

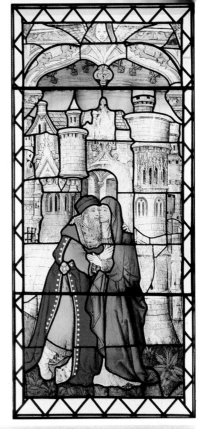

88 Joachim and Anna *(45/389),*
French or Rhineland,
early 16th century

89 Oliver 1802 –
milling mark on lead

7 November . . . To John Geddyng for 5lb of GEET for painted glass,
3s. 4d. Robert de Bodenham for 500 of TALSHED [firewood] bought
for the work of the glaziers and of the plumbers 26s. 8d.[70]

The leads, whether milled or cast, were soldered together using an alloy
which varied from 80 per cent lead and 20 per cent tin in the 12th century,
to 50 per cent lead and 50 per cent tin at the beginning of this century.[71]

A surprisingly large number of windows in the Burrell Collection still
have their original lead. These windows, along with those which have
been re-leaded and restored, provide a fascinating study of leads from
the 13th to the 20th centuries.

The final process before installation was to waterproof the entire
window with putty, or a glazing compound known as cement. This was
composed of boiled linseed oil, whiting, plaster of Paris, turpentine, red,

yellow or white lead, lampblack, metallic salts and sometimes pigments such as red ochre.[72] With time the putty, whatever its composition, polymerizes, becomes hard, cracks and eventually falls out. Rainwater collects in the cracks and corrodes the edges of the glass which lie hidden underneath the leads. The leads themselves become weakened through the continual stresses exerted upon them by the wind and the downward force of gravity. Without the extra support and flexibility offered by the putty, the lead bulges and finally cracks. When a window bulges, tremendous stresses are put on the glass, causing it to break.

To support a window, saddlebars must be fastened to the surface of the stained glass panels, with copper or lead ties. The saddlebars are held firmly in place at the sides of the window by channelling them into the stonework. Since the 11th century, large windows have not been made in one section, but in several smaller panels, usually no larger than about 60 cm (24 in) in height or width. These are either set into an iron gridwork called a ferramenta, or placed one on top of the other and supported by larger, stronger saddlebars called T bars.

Prior to the middle of the 12th century the overall size of a window opening was restricted because the walls had to be strong enough to support the roof. This problem was overcome by the invention of internal and external architectural supports, the latter known as flying buttresses, which carried the weight of the roof and enabled the walls to become lighter and the window openings larger and more elaborate. Stained glass was used to fill the openings, flooding the interiors with colour and light. As the Gothic style became the most dominant force in European art, stained glass emerged as one of its most important expressions.

Most windows that are very old have been re-leaded many times. During each re-leading, repairs are carried out on the glass, replacing broken pieces with new ones, and sometimes painting them to copy the old broken fragments. However, it is not uncommon for complete reconstructions to take place on the workbench, as happened to two 13th-century ecclesiastical saints. The figures of the *Priest and Bishop* (Fig 90) were illustrated in 1914 standing side by side in a round medallion with an ornate border and a narrow column in the centre.[73] Today they are separated and the surrounding medallion has been removed. The lower half of their legs, the ruby border with yellow castles and white circles and the architectural canopy above their heads are fragments of 13th-century glass which were added between 1914 and 1939.

It is the role of conservators and art historians to preserve and record this amazing collection of stained glass. This work is carried out in accordance with the guidelines of the Corpus Vitrearum Medii Aevi, which was formed in 1948 to record and conserve fully the world's medieval stained glass. The following statement is part of a document drawn up in 1989 by the CVMA Technical Committee:

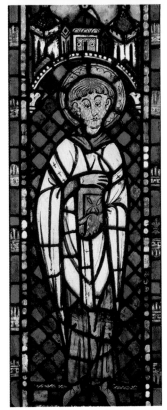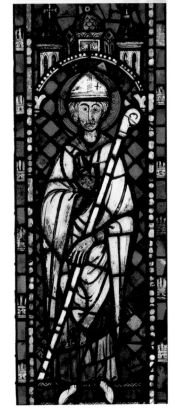

90 **Priest Saint and Bishop Saint** *(45/365), North German, 13th century*

Research and conservation are basically indivisible activities. The prerequisites for conservation should not only include technical study, but also art historical understanding; the historical development of artistic aspects, and of available materials and techniques (types of coloured glass, lead profiles, working methods, manner of painting, special technical characteristics and so on) are only meaningful in relation to each other, and they are equally relevant to the principles of restoration and conservation. Especially important is the history of the glass, because a knowledge of former restorations can be particularly informative about the nature of any damage it has suffered. The Corpus Vitrearum guidelines include such research, and the maintenance of files concerning the documentation of ancient stained and painted glass, as a basis for study.

The basic assumption is made that the restoration and conservation of monumental stained and painted glass requires the same attention and painstaking care as that of other works of art, such as paintings on panel, canvas or polychrome sculpture.

In July/August of 1941, Burrell sent a box to Wilfred Drake which contained 34 stained glass panels which had been bought about 50 years previously. Most of these he sold to Drake. The panels which he kept in the collection, and which are identifiable, are as follows:

> Item 2: Oval Armorial, size 8^1/$_2$ x 6^1/$_2$in (a three-masted ten-gun ship, crest, a star), Dutch 17th century (45/557)

> Item 13: Panel, 13^1/$_8$ x 9^1/$_2$in. The Virgin Mary and Infant Saviour. Arms and Crest of the Order of St John, and an inserted shield. Inscription: 'Brother Oswald Elsener, of the Order of St John Baptist'. St John the Divine and St John the Baptist above. Dated 1550, Swiss, 16th century (45/506)

> Item 16: Roundel, 6^1/$_4$in diameter. St Motker Balbulus of St Gall resisting temptation (flogging Satan with a broken stave). Inscription: 'The Blessed NOTKER BALBULUS MONK OF ST GALL. triumphed miraculously over the terrible deamon. Died AD 912. 6th April', Swiss, 17th century (45/529)

> Item 17: Roundel, 7^1/$_2$in diameter. Incidents in the life of a saint. As an infant he is held in the arms of an angel; later in life he is placed in the stocks while he sees a vision of the infernal regions. Below: the arms and crests of Wolfgang Keiser, Secretary of State and Member of Parliament for Zug, and his wife Mary Magdalene Schlumpf. Dated 1671, Swiss, 17th century (45/530)

Identifiable glass from 8 Great Western Terrace:

> 45/217, Shield of Stringer, English, 16th century

> 45/503, Heraldic panel with scenes of a metal foundry, Swiss, 16th century

> 45/537, Shield of Cornelis Abrams, Dutch, 17th century (This panel was in the front door of 8 Great Western Terrace)

> 45/551, Cook and Small Boy in Kitchen, Dutch, 17th century

> 45/613, Seven Women Beating a Man's Trousers, Dutch, 17th century

> 45/627, St Andrew, Swiss or German, 16th century

Sir William Burrell's glass from 1901 Exhibition:

> p 60 Against wall of Room III
> no 82 Stained glass panel, German, 16th century
> no 92 Stained glass panel, German, 16th century
> no 96 Stained glass panel, German, 16th century

> p 182 Case P
> no 6 Glass with inscription and domestic scene portrayed
> no 15 German glass – bear hunt with cover
> no 16 Dutch glass – coat of arms
> no 17 Dutch glass – etched with agricultural elements etc, and decorated green cover
> no 18 German glass – fishing scene
> no 19 German glass – tournament (45/499)
> no 22 Dutch glass with dockyard scene and inscription, 17th century
> no 23 Dutch glass with dockyard scene and inscription, 17th century
> no 25 Two swordsmen on horseback, Dutch glass, 17th century
> no 27 Dutch glass with Netherlandish coat of arms, 17th century
> no 28 Dutch glass – coat of arms and dancing scene
> no 29 Dutch glass with three figures
> no 37 Dutch glass, 17th century
> no 38 Dutch glass, 17th century
> no 39 Dutch glass, 17th century
> no 40 Dutch glass, 17th century
> no 42 Dutch glass with boar hunt
> no 43 Dutch glass with shipowner and captain, 17th century
> no 44 Dutch glass, 17th century
> no 45 Dutch glass, 17th century

APPENDIX 2 – Burrell Glass from Costessey

45/2 Beatrix van Valkenburg, English, late 13th century (Costessey Catalogue no 7)

45/131 Arms of John Howard, 1st Duke of Norfolk, English (Norwich School), c.1475, (Costessey Catalogue no 77)

45/132 Arms of John de Vere, 13th Earl of Oxford, English (Norwich School), c.1475, (Costessey Catalogue no 78)

45/377 St Cecilia and the Angels, German (Rhineland), 15th century (Costessey Catalogue no 69) (ex collection Lord Rochdale, bought 1948)

45/379 'Noli me tangere', French or German (Rhineland), 15th century (Costessey Catalogue no 65)

45/388 Assumption of the Virgin, French or German (Rhineland), 15th century (Costessey Catalogue no 73)

45/389 Joachim and Anna, French or German (Rhineland), early 16th century (Costessey Catalogue no 62)

45/390–2 Life of St John the Evangelist, French (Rouen – Church of St John), early 16th century (Costessey Catalogue no 56)

45/393–4 Tree of Jesse, French (Rouen), early 16th century (Costessey Catalogue no 59)

45/413 Presentation in the Temple, French or German (Rhineland), late 15th century (Costessey Catalogue no 64) (ex collection F. W. Bruce, bought 1939)

45/426 Miracle at Cana, German (Rhineland), 15th century (Costessey Catalogue no 18)

45/427 Adoration of the Magi, German (Rhineland), 15th century (Costessey Catalogue no 33)

45/431 Via Del Rosa, German (Rhineland), 15th century (Costessey Catalogue no 43) (ex collection Eumorfopoulos, bought 1945)

45/432 Solomon and Sheba, German (Rhineland), 15th century (Costessey Catalogue no 54) (ex collection Lord Rochdale, bought 1948)

45/433 The Ascension, German (Rhineland), 15th century (Costessey Catalogue no 22) (ex collection Lord Rochdale, bought 1948)

45/434 Mary Magdalene anoints Christ's feet, German (Rhineland), 15th century (Costessey Catalogue no 32) (ex collection Lord Rochdale, bought 1948)

45/435 Judgment of Solomon, German (Rhineland), 15th century (Costessey Catalogue no 36) (ex collection Lord Rochdale, bought 1948)

45/436 Female Donors and their Patron Saint, German (Rhineland), early 16th century (Costessey Catalogue no 76)

APPENDIX 3 – Burrell Glass from Hearst Collection

45/144, Royal Arms of England – garter medallion, English, 16th century

45/203, Oval medallion with badge of Henry VIII and Jane Seymour, English, 16th century

45/233, Royal Arms of England – garter medallion, English, 16th century

45/234, Oval medallion with badge of Henry VIII, English, 16th century

45/236, Unnamed shield – per fess gules and vert three hedgehogs proper, English, 16th century

45/237, Arms of Lewknor Impaling Lovelace, English, 16th century

45/365, Priest and Bishop Saints, North German, 13th century

45/366, Marriage at Cana, French (Clermont-Ferrand), 1275–85

45/372, Martyrdom of St Lawrence, and a Saint King, French, 14th century

45/382, Four scenes from the Life of Christ, French, early 15th century

45/383, St Stephen, South German, c.1400

45/410, Royal Arms of England within badge of the Order of St Michael, English, 16th century

45/480, Virgin and St John the Baptist, German (upper Rhineland), c.1310–20

45/481, Bust of praying angel, and canopy, Austrian, c.1425–50

45/485, Six scenes from the Life of Christ and the Virgin, German (Boppard-am-Rhein), 1440–6

45/486, Twelve scenes – religious, secular and heraldic, North German, late 14th or early 15th century

45/487, St Cunibert and Bishop Saint, German (Boppard-am-Rhein), 1440–6

NOTES

These Notes contain additional background information.
Authors referred to can be found in the Bibliography.

CHAPTER ONE

[1] Burrell is known to have owned about 32 pieces of glass around this time, but their exact date of purchase is not known. WB–WD, 21.7.41

[2] Horace Walpole's collection of medieval works of art at Strawberry Hill, which inspired many 19th century collectors, played no part in influencing Burrell as he did not know of Walpole's collection of stained glass until he was over 80 years old. Burrell archives

[3] Winston, 1865, pp 15–62

[4] The influence of the Glasgow School of glass painters is clearly demonstrated in their writings:
Winston, 1865, p 36, 'I think on the whole it is better to have art without transparency than transparency without art'; Adam, 1877, referring to the Munich windows: 'Art without transparency to transparency without art'

[5] It is a generally held misconception that the windows were disliked at the time of their installation. Contemporary writings show otherwise.
MacGregor Chalmers, 1914, p 76
Winston, 1865, p 320
Adam, 1877

[6] See note 1

[7] See Appendix 1

[8] Kent, 1937
Lafond, 1964

[9] Lafond, 1964, pp 58–62

[10] Copies of the sales catalogues were published in *British Society of Master Glass Painters (BSMGP) Journal* as follows:
1804 Sale: vol XII, no 1, 1955–6, pp 22–9
1808 Sale: vol X, no 4, 1951, pp 181–8
1816 Sale: vol VI, no 4, 1937, pp 217–20
1816 Sale: vol VIII, no 1, 1939, pp 15–17
1820 Sale: vol VI, no 3, 1936, pp 129–31

[11] Drake, M., 1920

[12] Wells, 1965, p 6

[13] *Glasgow Herald*, 7.2.23
Glasgow Herald, 13.9.19
Obituary, *BSMGP Journal*, vol 1, 1924

[14] Drake, M., 1920, p 12

[15] Wells, 1965, p 62

[16] Perrot, 1976–7, pp 38–41

[17] *BSMGP Journal*, vol X, no 4, 1947–51, p 184
Rackham, 1927, p 93

[18] Wells, 1965, p 69

[19] Winston, 1847, p 369

[20] Evans, 1982, pp 41–3

[21] Ibid, p 43
Le Couteur, 1926, p 42

[22] WB–WD, 10.9.38
WB–WD, 3.3.39

[23] WD–WB, 9.6.39

[24] Zakin, 1974, p 21

[25] Zakin, 1982, pp 23–30

[26] Photographs in Burrell archives

[27] Zakin, 1974, p 21

[28] Hayward, 1969

[29] Ibid, pp 81, 91, 93

[30] Ibid, p 79

[31] Ibid, p 83

[32] Ibid, pp 93–8

[33] I am grateful to Dr Jane Hayward for this information

[34] Hayward, 1969, p 93

[35] Ibid, p 85

[36] Wentzel, 1961, p 244

[37] Hayward, 1969, p 105

[38] Ibid, pp 86, 101–2

[39] Ibid, p 102

[40] The following information has been taken from official letters and private correspondence in the Burrell archives

[41] Letter dated 29.12.39

[42] Letter dated 5.1.40

[43] Letter, Drake–Midland Bank 15.1.40

[44] Marks, 1988, pp 129–30

[45] Wells, 1962, pp 36–46

[46] Cole 1775: Sandwiched between detailed descriptions of the glass is a 'Receit for weak eyes' as follows:
Heat *half an ounce of Lapis Caminans* red hot, & quench it in *half a pint* of *French White–Wine*, & *as much white Rose Water*: then pound it very fine & infuse it. Shake the Bottle whenever it is used. It has cured total Blindness.

[47] Drake, W., 1932, p 76

[48] Wentzel, 1961, pp 247–9

[49] Grodecki, 1961, p 179

[50] O'Conner and Gibson, 1986–7, pp 125–8

[51] Marks, 1987, pp 291–2

[52] WB–WD, 6.8.46

[53] Marks, 1988, pp 178–80

[54] The yellow mullet played an important role in the Battle of Barnet, 14 April 1471, when dense fog caused Henry VI's supporters to mistake it for the golden sun of Edward IV. In the ensuing confusion, the two armies who were both on Henry's side – de Vere and Somerset – slew each other, and hastened Henry's downfall (Seymour, 1979, pp 158–9, 161)

[55] Elton, 1962, pp 203–9

[56] Wells, 1962, p 51

[57] Varty, 1967

[58] Woodforde, 1950, pp 149–50

[59] Ibid, p 158

[60] Burrell liked this panel 'very much' WB–WD, 28.7.44

[61] Le Couteur, 1926, p 105
Woodforde, 1950, p 145

[62] Ibid, pp 16–42
King, D., 1982

[63] Perrot, 1976–7, pp 40, 41

[64] Drake, W., 1912, pp 127–54

[65] See Appendix 1

[66] Notman and Tennent, 1980, pp 165–75

[67] Tennent, 1980, pp 46–7

[68] WB–WD, 14.2.41

[69] WB–WD, 2.12.39
WB–WD, 21.2.39
WB–WD, 14.2.41
WB–WD, 17.2.41

[70] Letter in Burrell archives

[71] Marks, 1988, p 144

[72] Drake, W., 1932

[73] Marks, 1987, p 290

[74] WB–WD, 10.7.40
WB–WD, 2.10.40
WB–WD, 28.10.40

[75] WB–WD, 15.3.42
WB–WD, 23.3.42
WB–WD, 10.10.45

[76] WB–WD, 18.3.43
WB–WD, 21.12.44

[77] Marks, 1988, p 193

[78] Caviness, 1970

CHAPTER TWO

[1] Newton, 1982, p iii

[2] Newton (Turner Memorial Lecture), 1985, p 98

[3] Ibid, p 99

[4] Newton, 1982, p iii
Newton (Turner Memorial Lecture), 1985, pp 100–1

[5] Newton and Davison, 1989, p 57

[6] Newton, 1982, pp iii–iv, viii
Newton (Durability of Glass), 1985, p 28

[7] Hawthorne and Smith, 1979, p 49

[8] Newton, 1982, p iii
An interesting reason for the change was given by Noel Heaton in 1948 (BSMGPJ), in suggesting that the mass destruction of forests in the 16th century caused the glass-makers to look for other supplies (p 15)

[9] Blancourt, 1699, pp 35–6

[10] Ibid, p 40

[11] Newton and Davison, 1989, p v
Newton (Turner Memorial Lecture), 1985, pp 99–101

[12] Hawthorne and Smith, 1979, p 57

[13] Newton and Davison, 1989, p 58

[14] Ibid, p 10

[15] Blancourt, 1699, pp 62–3

[16] Newton, 1982, p vii

[17] Blancourt, 1699, pp 24–5, 27

[18] Drake, M., pp 23, 41, pl xvi
Le Couteur, 1926, p 6
Newton and Davison, 1989, p 58

[19] Newton, Brighton and Taylor, 1989, pp 34–9
(Ibid, Peckitt took out a patent (no 1268) for this tool in 1790)

[20] Winston, 1865, pp 9–13, 182

[21] Hawthorne and Smith, 1979, p 61

[22] As can be seen at York Minster and Wells Cathedral. I am indebted to Professor Roy Newton for this information

[23] Le Couteur, 1926, p 17
Osbourne, 1981, p 49

[24] Thompson, 1960, p 111

[25] Waymont, pp 23–8

[26] Rode, 1974, p 61, fig 396

[27] Hawthorne and Smith, 1979, pp 62–3

[28] Drake, M., 1912, p 74
Le Couteur, 1926, p 12

[29] Twining, 1928, p 95

[30] Elskus, 1980, pp 22–9
Hawthorne and Smith, 1979, p 63
Newton and Davison, 1989, p 96

[31] All recipe and firing information in Gedde's book is at the back; however, no page numbers are given. Inconsistencies in spelling are as they appear in the text.

[32] Saltzman, 1928, p 120

[33] For instance, Pupil of Arnoult de Nijmegue (Fig 6), *W. Butlim of Daventry* (Fig 22)

[34] She was a 5th-century Alexandrian who, on being turned away from the Church of the Holy Sepulchre in Jerusalem by a vision of the Virgin, ceased her sinful ways, and spent the rest of her life in the desert. During this time she ate three small loaves, and was eventually buried by a lion!

[35] Le Couteur, 1926, pp 103, 110, 130

[36] Blancourt, 1699, pp 282–3

[37] Hawthorne and Smith, 1979, pp 65–7

[38] Thompson, 1960, p 111

[39] Gedde, 1615

[40] Blancourt, 1699, pp 269–72

[41] Winston, 1847, p 18

[42] Whall, 1905, pp 105–17

[43] Newton, Brighton and Taylor, 1989, p 37

[44] Blancourt, 1699, pp 283–5

[45] Gedde, 1615

[46] WB–WD, 29.11.43

[47] Caviness, 1981, pp 251–67

[48] Rackham, 1948, p 156
Le Couteur, 1926, p 160

[49] WB–WD, 29.4.39

[50] Caviness, 1981, pp 257–8

[51] Newton and Davison, 1989, pp 99–100
Heaton, 1948, pp 15–16

[52] Newton and Davison, 1989, p 84

[53] Professor Roy Newton suggests that one reason for this lack of communication may be because vessel glass enamels tended to be opaque whereas transparency was required by the stained glass artists. (Private correspondence RN-LC)

[54] Blancourt, 1699, pp 274–7
Gedde, 1615

[55] Newton, Brighton and Taylor, 1989, pp 35–6

[56] Newton and Davison, 1989, p 157

[57] Grodecki, 1953, p 28
Brisac, 1984, pp 131, 183
Lafond, 1966, p 39

[58] Brisac, 1984, p 131

[59] Blancourt, 1699, pp 275–6

[60] Lafond, 1966, pp 38–9 (Author's translation)

[61] Wells, 1962, p 31

[62] Hawthorne and Smith, 1979, pp 71–2

[63] It is a commonly held belief that lead that is 100 per cent pure is the most suitable type for making calmes. Present research is showing that this is not the case, and that certain impurities can aid the longevity and workability of the calme. The overall effectiveness of lead is not solely due to its composition, its profile and method of manufacture are also vitally important.

[64] Knowles, 1930, pp 133–6
Hawthorne and Smith, pp 67–70
Deneux, 1928, pp 81–4

[65] Knight, 1983–4, pp 49–51

[66] Knowles, 1930 'The earliest instance occurs in the mechanical drawings of Leonardo da Vinci about the year 1500, where there is a diagram for "drawing lead for glass windows".'

[67] Rollason, 1965, pp 8, 98–117, 121

[68] Cannon, 1988, pp 262–72

[69] Gold, 1965, pp 15–16

[70] Saltzman, 1927, p 39

[71] Hawthorne and Smith, 1979, p 70
Duthie, 1982, p 46

[72] Sloan, 1990, pp 32–5

[73] Cassirer, 1914

SELECTIVE BIBLIOGRAPHY

Adam, Stephen, *Stained Glass – Its History and Modern Development*, Glasgow 1877

Blancourt, Haudicquer de, *The Art of Glass*, London, 1699

Brisac, Catherine, *A Thousand Years of Stained Glass*, MacDonald & Co, London, 1984

Cannon, Linda, 'Lead Milling Marks from a Sixteenth-Century Stained Glass Window', *BSMGP Journal*, vol XVIII, no 3, 1988, pp 262–72

Cassirer, Bruno, *Die Glasmalerei*, Berlin, 1914

Caviness, Madeline, 'Fifteenth-Century Glass from the Chapel of Hampton Court, Herefordshire: the Apostles' Creed and Other Subjects', *The Walpole Society*, vol 42, March 1970

Caviness, Madeline Harrison, 'The Windows of Christ Church Cathedral, Canterbury', *CVMA Great Britain*, vol II, OUP, Oxford, 1981

Cole, Rev William, *His diary, Tarporley in Cheshire* (British Museum MS 5830), copy in Burrell archives, 1755, 39–45

Deneux, H., 'A Thirteenth-Century Mould for Making Calm Lead', *BSMGP Journal*, vol 87, no 2, 1929

Donnelly, Michael, *Glasgow Stained Glass*, Glasgow Museums and Art Galleries, 1981

Drake, Maurice, *A History of English Glass Painting*, London, 1912

Drake, Maurice, *The Costessey Collection of Stained Glass*, Exeter, 1920

Drake, Wilfred, 'List of Ancient Stained Glass at Hutton Castle', Burrell archives, 1932

Drake, Wilfred, *A Dictionary of Glass Painters and Glasyers of the Tenth to the Eighteenth Centuries*, Metropolitan Museum of Art, New York, 1955

Duthie, Arthur Louis, *Decorative Glass Processes*, Dover, New York, 1982

Elskus, Albinas, *The Art of Painting on Glass*, Schribners, New York, 1980

Elton, G. R., *England Under The Tudors*, Methuen, London, 1962

Evans, David, *A Bibliography of Stained Glass*, D. S. Brewer, Woodbridge, Suffolk, 1982

Gedde, Walter, *A Booke of Sundry Draughtes (a facsimile of a book of designs for leaded glass first printed 1615)*, Walter Dight, London, 1898

Glasgow International Exhibition 1901, Official Catalogue of the Fine Art Section, Glasgow, 1901

Gold, Sidney, *John Rowell*, Ranelagh Press, 1965

Grodecki, Louis, *Vitraux de France*, Paris, 1953

Grodecki, Louis, *Les Vitraux de Saint-Denis*, Forty Essays in Honour of Erwin Panofsky, Ed. Meiss, Millard, New York, 1961

Grodecki, Louis, *Les Vitraux de Saint-Denis*, CVMA, Paris, 1976

Hawthorne, J. G. and Smith, C. S., *On Divers Arts*, Dover, New York, 1979

Hayward, Jane, 'Stained Glass Windows from the Carmelite Church at Boppard-am-Rhein', *Metropolitan Museum Journal*, vol 2, Metropolitan Museum of Art, New York, 1969

Kent, E., 'John Christopher Hampp of Norwich', *BSMGP Journal*, vol VI, no 4, 1937, pp 191–6

King, David, 'New Light on the Medieval Glazing of the Church of St Peter Mancroft', *Crown in Glory*, Jarrold, Norwich, 1982, pp 18–22

Knight, Barry, 'Researches on Medieval Window Leads', *BSMGP Journal*, vol XVIII, no 1, 1983–4, pp 49–51

Knowles, J., 'Ancient Leads for Windows and the Methods of their Manufacture', *BSMGP Journal*, vol VII, no 3, 1930

Lafond, J., 'Traffic in Old Stained Glass from Abroad', *BSMGP Journal*, vol XIV, no 1, 1964, pp 58–67

Lafond, Jean, *Le Vitrail Libraire Artrieme Fayard*, Paris, 1966

Le Couteur, J. D., *English Medieval Painted Glass*, SPCK, London, 1926

MacGregor Chalmers, P., *Stained Glass in Glasgow Cathedral and See*, G. Bell, London, 1914

Marks, Richard, *New Acquisitions – Burrell Collection*, Glasgow Art Gallery and Museums Association, Calendar of Events, 1982, p 3

Marks, Richard, *Arms of Somery, Age of Chivalry Exhibition Catalogue*, p 291, Royal Academy of Arts, London, 1987

Marks, Richard, *Portrait of a Collector*, Richard Drew, Glasgow, 1988

Newton, R. G., *The Deterioration and Conservation of Painted Glass: A critical bibliography*, CVMA, Great Britain, Occasional Papers II published for the British Academy by the Oxford University Press, 1982

Newton, R. G., 'The Durability of Glass – a review', *Glass Technology*, vol 26, no 1, February 1985

Newton, R. G., 'W. E. S. Turner – Recollections and Developments' (Eighth Turner Memorial Lecture), *Glass Technology*, vol 26, no 2, April 1985, pp 93–103

Newton, R. G., Brighton, J. T. and Taylor, J. R., 'Peckitt's Treatise on Glasses and Stains for them', *Glass Technology*, vol 30, no 1, February 1989, pp 33–8

Newton, R. G. and Davison, Sandra, *Conservation of Glass*, Butterworth, Sevenoaks, 1989

Notman, Janet and Tennent, Norman, 'The Conservation and Restoration of a 17th-Century Stained Glass Roundel', *Studies in Conservation*, 25, 1980

O'Connor, David and Gibson, Peter, 'The Chapel Windows at Raby Castle', *BSMGP Journal*, vol XVIII, no 2, 1986–7, pp 124–49

Osbourne, June, *Stained Glass in England*, Frederick Muller, London, 1981

Perrot, Françoise, 'Des Vitraux Rouennais Retrouvés en Angleterre', *Bulletin des Amis des Monuments Rouennais*, 1976–7

Rackham, Bernard, 'English Importations of Foreign Stained Glass in the Early Nineteenth Century', *BSMGP Journal*, vol II, no 2, October 1927, pp 86–94

Rackham, Bernard, *The Ancient Stained Glass of Canterbury Cathedral*, Lund Humphries, London, 1948

Rode, Herbert, *Die Mittelalterlichen Glasmalereien Des Kölner Domes*, CVMA, Berlin, 1974

Rollason, E. C., *Metallurgy for Engineers*, Edward Arnold, London, 1965

Rylands, J. Paul and Stewart-Brown, R., 'Armorial Glass at Vale Royal, Spurstow Hall, Uckington Hall, and Tarporley Rectory, in the County of Cheshire', *Genealogist*, vol XXXVIII, 1922

Saltzman, L. F., 'The Glazing of St Stephen's Chapel, Westminster, 1351–2', *BSMGP Journal*, vol II, no 1, 1927, pp 38–41

Saltzman, L. F., 'Medieval Glazing Accounts (I)', *BSMGP Journal*, vol II, no 3, 1928, pp 116–20

Schreiner, Manfred, *Analytical Investigations of Medieval Glass Paintings*, University of London Institute of Archaeology Jubilee Conference, 1987, pp 73–80

Seymour, William, *The Battles of Britain, 1066–1746, vol I*, Sidgwick and Jackson, London, 1979

Sloan, Julie, 'The Particulars of Putty', *Stained Glass Association of America Magazine*, April 1990, pp 30–9

Tennent, Norman, 'A Stained Glass Roundel from the St Francis Cycle by Michael Muller IV', *Scottish Art Review*, vol XVI, no 1

Thompson, Daniel V. Jr, *The Craftsman's Handbook – Il Libro dell' Arte, Cennino d'Andrea Cennini*, Dover, New York, 1960

Twining, E. W., *The Art and Craft of Stained Glass*, Pitman Press, London, 1928

Varty, Kenneth, *Reynard the Fox*, LUP, London 1967

Waymont, Hilary, 'The Glaziers' Sorting Marks at Fairford', *Crown in Glory*, Jarrold, Norwich, 1982, pp 23–8

Wells, William, *Stained and Painted Heraldic Glass in the Burrell Collection*, Glasgow Museums and Art Galleries, 1962

Wells, William, *Stained and Painted Glass in the Burrell Collection*, Glasgow Museums and Art Galleries, 1965

Wentzel, Hans, 'Die Farbfenster des 13. Jahrhunderts in der Stiftskirche zu Brucken an der Weser', *Niederdeutsche Beitrage zur Kunstgeschichte*, vols I-III, 1961–4

Wentzel, Hans, 'Unknown Medieval Stained Glass in the Burrell Collection, part one', *Pantheon*, vol XIX, May-June, 1961

Whall, Christopher, *Stained Glass Work*, Spottiswoode, Ballantine, London, 1905

Winston, Charles, *Hints on Glass Painting* (2 vols), John Henry Parker, Oxford, 1847

Winston, Charles, *Art of Glass Painting*, John Murray, London, 1865

Woodforde, Christopher, *The Norwich School of Glass Painting in the Fifteenth Century*, OUP, Oxford, 1950

Zakin, Helen, *Medieval Art in Upstate New York*, Exhibition Catalogue, entry no 9 – France, Clermont-Ferrand, Syracuse, NY, 1974

Zakin, Helen Jackson, 'Three Stained Glass Panels from Clermont-Ferrand', *Porticus* (Journal of Memorial Art Gallery, University of Rochester), vol V, Rochester, New York, 1982